Getting into

Art & Design Courses

James Burnett

10th edition

trotman

Getting Into guides

Getting into Art & Design Courses, 10th edition
Getting into Business & Economics Courses, 11th edition
Getting into Dental School, 9th edition
Getting into Engineering Courses, 3rd edition
Getting into Law, 11th edition
Getting into Medical School 2017 Entry, 21st edition
Getting into Nursing & Midwifery Courses, 1st edition
Getting into Oxford & Cambridge 2017 Entry, 19th edition
Getting into Pharmacy and Pharmacology Courses, 1st edition
Getting into Physiotherapy Courses, 8th edition
Getting into Psychology Courses, 11th edition
Getting into Veterinary School, 10th edition
How to Complete Your UCAS Application 2017 Entry, 28th edition

Getting into Art & Design Courses

This 10th edition published in 2016 by Trotman Education, an imprint of Crimson Publishing Ltd, 19–21c Charles Street, Bath BA1 1HX

© Trotman Education 2008, 2009, 2010, 2012, 2014, 2016

© Trotman & Co. Ltd 2003, 2004, 2006

Author: James Burnett

4th–9th edns: James Burnett
3rd edn: James Burnett and Jonathan Hollins
1st–2nd edns: Jonathan Hollins

British Library Cataloguing in Publication Data
A catalogue record for this book is available from the British Library

ISBN 978 11 922067 20 7

Typeset by IDSUK (DataConnection) Ltd
Printed and bound in the UK by TJ International Ltd, Padstow, Cornwall

Contents

Contents

About the author

James Burnett is Director of Studies and a careers and university adviser at Mander Portman Woodward (MPW). He has written a number of the Trotman/MPW guides, including *Getting into Engineering Courses*. He works with a number of schools on university interview preparation and portfolio reviews, and runs courses, workshops and seminars on UK university applications in a number of countries, including Malaysia, Indonesia, Singapore and Thailand.

Acknowledgements

This book would not have been possible without the involvement of a great many people. In particular, I would like to thank Jonathan Hollins, who was the main contributor to and driving force behind the first edition of this book, and Beryl Dixon for her work on the second edition and the earlier incarnation of the book. Thank you also to Ross Hulbert from Falmouth University, Annabel Knowles, Kieran Wye, Jessye Bloomfield, Rosa Nico de Graaf, Justin Lee, Bill Watson, Dr Mary O'Neill and Michelle Palmer from the University of Lincoln, Stella Sinclair from Edinburgh College of Art, Ellie Ducker from the Arts Institute at Bournemouth, and David Girling and Sarah Horton at Norwich University of the Arts for their expertise, help, advice and written contributions. My colleagues in MPW's art department (Mark Cheeseman, Louise De La Hey, Kate Brett, Kevin Newark) provided contributions to the book and invaluable advice on preparing students for their art school applications. Thank you also to Harriet Blomefield, Ralph Kiggell, Akiko Hirai and Gerard Hastings for their contributions on the rewards and demands of working as artists.

Plates 4, 5 and 6 are reproduced with the kind permission of Falmouth University. Plate 7 is reproduced with the kind permission of Norwich University of the Arts.

James Burnett
November 2015

Introduction

When I am writing, I often have the radio on in the background. As I write this, snippets from the news vaguely register. There is a fuss about the design for the 2020 Tokyo Olympics stadium, 13 million handsets of the new Apple phone – a record – were sold in the first three days of its release, a painting by a contemporary British artist was sold for £17 million at a recent auction, a reviewer is recommending a new book about the history of porcelain. What link all of these are British art schools and universities. Zaha Hadid (who recently became the first woman to be awarded the Royal Institute of British Architects Gold Medal, one of the most prestigious architecture awards), who won the commission for the Tokyo stadium, studied at the Architectural Association School of Architecture in London. The driving force behind the design of Apple products is Jonathan Ive, who studied Industrial Design at Northumbria University. The painter Peter Doig studied at colleges that are now part of the University of the Arts. The potter Edmund De Waal has written a new book about his personal journey to discover the history of porcelain. Of course, not everyone who studies art and design at art school or college will make news headlines. But it says something about the importance of art and design to us all that these things are thought to matter enough to be reported on national TV and radio. At the same time as these events were taking place, thousands of recent art and design graduates from art schools, colleges and universities were starting careers in areas as diverse as fashion marketing, art restoration, web design, advertising and architecture; while others were taking their first steps into producing and selling their work by setting up small design and craft businesses.

A walk down any town's high street will immediately demonstrate the importance of fashion designers to the way in which we spend our money; and graphic designers and web designers persuade us to buy the latest music, television sets or ready-meals. The constantly changing skylines of the world's great cities reminds us of how important architects are to our lives. As you will see in Chapter 1, studying at art school is not just about fine art (painting, sculpture, etc.), but an opportunity to focus your creative talents on disciplines that lead to exciting (and often lucrative) jobs.

In applying to art school you are taking the first step towards what will hopefully become not only your chosen career but also a lifetime journey of experimentation, invention and discovery. Perhaps you already have a strong feeling for a particular discipline, such as fine art, film or

fashion and textiles. Or maybe you are unsure which discipline is for you but just know that your instinct to work with colour, line, form, shape and pattern – to question, experiment and explore – is something that you have to develop. Either way, this book is specifically designed for you.

What is this book about?

You may be asking yourself the following:

- Which course(s) should I take?
- Where should I apply to study?
- What should I include in my portfolio?
- How do I prepare for an interview?

This book offers practical answers to these questions and many others, and aims to guide you successfully through the application process.

Routes for art and design students

Entry to an art and design degree is usually a little more complicated than entry to other degree courses – that is one of the reasons why this book has been written. Figure 1 gives an overview of the range of entry routes available; each of these will be examined in detail as the book progresses.

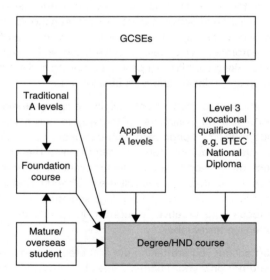

Figure 1: Entry routes

Who is this book for?

This book covers the procedure for applications for both Foundation studies and undergraduate degree courses in art and design, and for students thinking about architecture. If you are currently studying at A level you will find all chapters of this guide relevant. If you are studying for Applied A levels, the BTEC National Diploma or similar qualifications, you may be tempted not to read Chapter 2. However, it is recommended that you do read it, because it will help you to know what other students have been up to. The entry routes for architecture courses are outlined in Chapter 4.

If you are a student applying from outside the UK or a mature student, you will have to think about some other considerations. Most of what is contained in this book will apply, and there is additional information in Chapter 6 and the 'Non-standard applications' section in Chapter 5 (see page 51). Throughout the book, the entrance procedures have been illustrated with reference to A levels but the information is equally relevant to students studying for Scottish Highers, the International Baccalaureate or the Irish Leaving Certificate. If you have any questions about whether your academic qualifications will satisfy the art schools, you should contact them directly.

How should I use this book?

Read it. No, really! Just having the book on the shelf will not get you into art school. Discuss the information and ideas contained within it. Speak to your tutors, friends and parents. You will find it helpful to talk things through. Certain chapters have checklists: use these to help you keep track of your progress. Above all, take action – and when you have finished the book you should have a clear idea of where action is needed. If, for example, you realise that you probably need to do some more life drawing, then go and do some. Admissions tutors are, in any case, always interested in the work applicants have done in their own time, i.e. not just pieces they have done for A level coursework or exams.

You will feel far more confident about your application if you know that you have done everything that you possibly can to help yourself, and reading this book – then acting on what you find out – is the best way to start.

1 | Careers in art and design

Wherever you are right now, take a look around you. Look closely at the environment you are in and think about the contribution made to your surroundings by artists and designers. Some may be obvious: there might be a painting on the wall or you could take a look at the front cover of this book. If you are sitting on a chair, consider its design. Is it comfortable? If there is fabric covering the seat, what do you think of the colour and pattern? Look at the clothes you're wearing. Who was responsible for the cut and style? Who designed the fastening on your trousers? Where would you be without that? At home, consider the ergonomic design of your laptop and the artwork for the music that you download on it. Think about the packaging of the food that you eat and the shape of the cutlery that you eat with. Who took the fashion photographs in the magazine that you have just read? Who created the cover design? Who designed the logo? You may have done some research on art schools before reading this chapter – those websites were all designed by someone.

Artists and designers do not just exhibit their work in galleries and exhibitions. They are involved in almost all aspects of our day-to-day living. Artists and designers are concerned with how things look, feel and function. Virtually everything that is manufactured is designed to some extent. Most elements of the media – newspapers, magazines, television, websites, advertising – have considerable input from artists and designers. For every household name that emerges from art school to become rich and famous, there are many thousands of graduates who take up exciting careers that allow them to use their creative talents.

Studying a creative subject will also give you skills and approaches that are valuable in many careers that are not directly 'creative'. You will learn how to communicate using visual information, and you will gain analytical and problem-solving skills. Importantly, by studying alongside other creative people, you will learn to trust your own ideas and to work independently.

If you plan to study something like mathematics at university (but, as you are reading this book, you probably don't!) then you don't need to have a definite idea of what you want to do after graduating, because a mathematics degree can lead to hundreds of different careers, including those that are not directly related to the subject, such as banking,

finance or management. But a degree in costume for performance, for example, offers you fewer options, so you need to be reasonably sure that a career as a ballet or theatre costume designer is what you are aiming for. Gaining work experience prior to your application is, therefore, not only important in convincing the selectors that you are serious but also will ensure you are heading in a direction that is right for you. If you are passionate about research into make-up for example and know that this is the only thing you want to do, then choose the degree course in cosmetic science, rather than something less focused.

Most universities offer excellent careers advice (for example, have a look at the resources section for graduates on the University of the Arts London website: www.arts.ac.uk/student-jobs-and-careers), but in the case of art and design students, it is important to have thought about possible careers before choosing a degree course. This is why the Foundation course is an important aspect of an art education, because it gives you time to look at degree courses in more detail before committing yourself. Many art and design degree courses are very specialised and will give you a relatively narrow range of options, so you need to be sure that you are choosing a degree course that is going to get you where you want to be.

Considering your career options

A helpful approach when considering career options is to appreciate that the creative skills you possess are key skills. That is to say, your ability to understand and communicate using visual language is as fundamental as being able to understand and use mathematics.

Your talents will always be needed, especially when people are exploring new ideas. Landing on the moon, for example, was a great technological achievement and may not at first seem to have much to do with art and design – but you can be sure that designers were involved every step of the way. Think about it – a footwear designer would have helped to design Neil Armstrong's space boots; perhaps they went on to work for Gucci! Looking at things in this way will help you to keep an open mind.

Most students who apply to art and design courses do so because they have a passion for art, and the ability to be creative. Some students say that their intention, after graduating, is to 'become an artist', by which they mean that they would like to use their creative skills in a way that is not manipulated by financial or corporate issues – perhaps they intend to have their own studio, to exhibit their work and to become respected and admired by those who understand and value what they create. Realistically, however, not everyone has the talent, the focus, the energy or the luck to make a living in this way, but this

is only one of the options available to those completing a course in art and design.

What do art and design graduates do?

A reasonably high proportion of art and design graduates work on a freelance basis or are self-employed (see the section 'Working as an artist …' on page 9). This can be extremely stimulating and satisfying because you can, to a certain extent, pick and choose the type of work that you wish to undertake. However, it can also be stressful at times because you will need to combine your creative expertise with your skills in business. For some, this is not always a good combination.

Generally, employment rates for art and design graduates are pretty good, with about three-quarters of those looking for work finding it within a few months of graduating – although you need to bear in mind that for some this will mean involvement in short-term projects or contracts.

What do graduates do? (www.hecsu.ac.uk/current_projects_what_do_graduates_do.htm), which is published annually, aims to give a picture of what the graduates from one subject area in one particular year are doing. Information taken from the 2015 publication shows that of 3,000 fine art students who graduated in 2013 and responded to the survey, 70% were in employment while around 14% were undertaking further studies, either full- or part-time; 80% of design graduates were in employment, with a further 4% still studying. Nearly 40% of the employed design graduates were working in art, design or as media professionals; the corresponding figure for fine art graduates was 23%.

Other art and design graduates were working in a variety of jobs, including marketing, sales, public relations, commercial and public-sector management, buying, retailing, catering and general administrative work. In other words, some were using their degrees as a generalist qualification; others were in temporary employment – just like graduates in other subjects. A list of publications that provide information on careers and employment rates is given in Chapter 12.

Where might your degree lead?

For the purpose of career options, degree courses can be divided into two categories: the fine arts and the applied arts. Examples of the first category include painting, drawing and sculpture, and some photography and textile courses. The second category includes an enormous range of options, such as communications, fashion design, furniture

design, art restoration, jewellery design, television and film design, photojournalism and architectural photography. On many of these applied courses you will be developing skills specifically designed to help you meet employers' needs. If your degree falls into the second category, then you may well find businesses that are looking for someone with your specific qualifications. However, as a fine art student who, say, used digital manipulation techniques extensively in your work, you can apply to companies that are as interested in your thorough understanding of that particular software program as they are in your overall digital manipulation skills. This 'cross-over' ability demonstrates the value of key skills and will greatly increase your chances of having a successful working life.

The creative and visual communication skills that art and design graduates possess also make them very suitable for a range of interesting jobs within the field of art and design, such as:

- museum or gallery curator
- museum or gallery guide
- art director for magazines, TV or film
- researcher for TV arts programmes
- arts journalist or reviewer
- auctioneer
- arts events organiser.

Figure 2 will give you some idea of the range of job sectors to which specific degree courses might lead you.

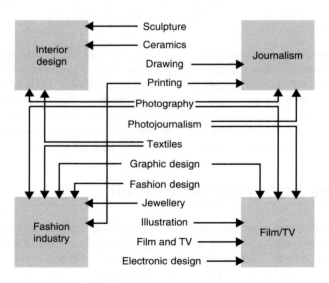

Figure 2: Job opportunities

Some of the careers that you might consider are:

- accessory design
- animation
- architectural and industrial photography
- architectural glass
- art restoration
- art therapy
- book illustration
- carpet design
- ceramics
- computer games
- costume design
- craft design
- digital imaging
- exhibition design
- fashion design
- fashion photography
- film and video
- glassblowing
- graphic design
- interior decoration
- jewellery
- journalism
- medical illustration
- model-making
- museums and galleries
- newspaper and magazine design
- packaging design
- printmaking
- public arts
- publishing
- sculpture
- surface pattern design
- tapestry
- teaching
- technical illustration
- textile and fabric design
- theatre design
- video and film production
- web design.

'Working as an artist ...'

The views of people working as artists included below should give you more of an idea of what to expect and how to make a success of your career.

'The daunting thing about moving from a full-time job to being a self-employed artist is quite simply dealing with a lack of structure and without a regular income. Without a regular salary one needs to ensure that cash flow is constant; worrying about money is not going to help you get inspired so being efficient with finances is essential. Structure applies to the departure from a set working day, and I advise any artist to set themselves a relatively strict daily plan, as without this it is easy to veer off course and reduce productivity. While creating art for yourself can be flexible, if you are doing it to earn money you need to treat it like a job.

'We are lucky to live in a world that allows anyone within reach of a computer to build up an online profile. Every artist should create a website through which they can present their work; alongside this, getting onto sites such as Artfinder allows artists to build up their exposure. Linking websites to Twitter, Instagram and Facebook can help get a name spread even further.

'Artists need commissions! It is important to spread the word about what you do, one commission could lead to many more. Don't be shy about talking about what you do as you never know what might come out of it. If you want to exhibit your work there are many different options out there, from renting a gallery space to seeing if any local shops or pubs want to lend you some wall space for a small fee. Things will only happen if you make them happen!

'The greatest positive of being an artist is that you get to dictate where you want to go and what you want to do. Don't be scared of taking the plunge and going full-time, just make sure you are in a position to support yourself, are structured and have a clear plan of action in terms of making it profitable.'

Harriet Blomefield, painter

'Working as an artist, like any other occupation, has its rewards and its drawbacks; it is immensely fulfilling and exciting but also exceptionally hard work. You need to be very self-reliant and resourceful (sometimes even ruthless) to be able to drive a project forward, be it a single work or an exhibition. An artist requires energy, organisational skills, innovation and, of course, insight – as you have to have something to communicate in your work. The best advice I can give is never stop working – if you don't paint you're not a painter; if you don't make art you are not an artist. Even when walking down the street I am always looking, always trying to solve pictorial problems or sorting out ideas. Carry sketchbooks, cameras or notebooks; you can't switch off being an artist – you are on duty all the time. An artist's life is never dull or mundane but full of enthusiasm and exciting possibilities. I know few artists who survive entirely by selling their work; most are uncommonly innovative and part of their professional activities entails teaching, framing, photography, conservation, organising exhibitions, writing, gallery and museum work. An artist's life is an exhilarating but unpredictable journey, full of unexpected twists and stimulating turns, but it is not a voyage which should be attempted by the faint-hearted!'

Gerard Hastings, painter and photographer

'Working as an artist is not much different from any kind of independent work. Put bluntly, you create a product and hope that people will like it. However, as an artist you need to balance integrity and skill with marketing. People will respect the quality, honesty and individuality of your work. They will appreciate your skills, which will be your natural abilities combined with hard practice and training. But people can only see your work if you are showing it. Much of your work as an artist is taking your art outside the studio. You can introduce your work to others as a teacher or guest lecturer or artist in residence. You should

find opportunities to be with other artists and discuss your work as well as exhibit together. You can also hold solo shows, or solicit projects that can showcase your work. Even if you are not selling, you need to continue to build up a portfolio and stick to your vision. As an artist you are your own boss for better or worse, but with discipline and integrity, there is no reason why you cannot succeed.'

Ralph Kiggell, contemporary woodblock artist

'Working as an artist, you experience the ups and downs of life, but I think these mostly happen in your mind. You are constantly learning from your experiences and it is natural that there are many events that you cannot control in your life. Some are good, some are bad; therefore you can be overwhelmingly excited or feel terribly let down. The important thing is to keep yourself steady and carry on with what you are doing. Constant analysis of what happened is always a good opportunity to improve your situation. Art has trends like anything else. You are naturally influenced by those trends when you try to be successful in what you do and you can easily get lost in the current climate. However, you cannot develop your own language fully by following those trends. Your work cannot be imitating other people's ideas.'

Akiko Hirai, ceramicist

Many artists need to combine their creative work with other jobs, because they cannot support themselves from selling their work. Others choose to combine careers as artists with work in other fields because it helps them to gain a sense of perspective in their creative processes.

'Having an avenue to express one's inner thoughts and creativity is fundamental to a fulfilled life. Before embarking on a Foundation course in art and design I was unable to see a clear path to pursue my interests in a positive way.

'While at school, students are at an important crossroads in their development as individuals, and as they warm to particular disciplines in the arts they begin to see themselves much more within the context of their own creative interests. In my experience, art school further establishes this self-recognition as an artistic identity is forged, connecting signature, style and individual.

'Outside the structure/comfort of education it can be difficult to make challenging new work; however, art school teaches you to become much more independent and responsible for your own work in a positive way.

'Perhaps the most exciting thing about art school is the opportunity to develop alongside likeminded students. Teaching,

facilities, workshops and individual tutors can play an important part in education at university; however, what you gain from your peers is priceless.

'Teaching has given me new perspectives on my practice as a photographer and educator. Seeing students make discoveries for themselves is one of the most rewarding experiences for a teacher. Art school is a way of engineering an environment that encourages students to make giant leaps forward in their work.

'Going to art school was perhaps the single most important decision I made in my professional life.

'Creating my own work alongside teaching students at sixth form and at university keeps me connected to the process and pattern of creative thinking.'

Kevin Newark, photographer, university lecturer and A level teacher

Further research

If you are sure that you want a career in a creative field, but unsure about the exact field at the point when you're trying to choose your degree course, then it might be better to choose something more general, such as fine art or graphic design. In order to get a better idea about possible careers, your research could include:

- doing work experience
- talking to school or college careers departments
- looking at university websites
- talking to practitioners
- visiting professional bodies (such as the Design Council – see Chapter 12 for contact details)
- taking a one-year art Foundation course (see Chapter 2).

Work experience and internships

If you are considering a career in art or design, you should take every opportunity available to gain work experience, internships or other relevant experience. There are two reasons for this:

1 You will find it easier to convince potential employers and university admissions staff that you are serious about a career or study in your chosen field if you can demonstrate that you have investigated it thoroughly.
2 You will have the chance to see whether the path that you have chosen is right for you.

Getting work experience or internships will require you to do a lot of investigation and to use your contacts, parents' contacts and teachers to help you. Being shy or passive and hoping that opportunities will knock on your door is unlikely to work. Having the courage to demonstrate your talent and creativity to people you do not know is something you will need if you want to have a career as an artist or designer, so as well as being an important part of your journey into art and design, it is also a vital quality for a successful career.

What should you look for?

- Part-time work in galleries, at exhibitions or art shows.
- Part-time work in other creative environments, such as advertising agencies, architecture firms, magazine publishers, fashion companies and interior design businesses.
- Opportunities to help set up school or college art shows.
- Work on blogs, websites or other social media.

'It is important to expand your experience beyond your art course at school and university and start to think about how you can make a living and career that is both fulfilling and creative, as well as remunerative. For example, while you are a student consider joining a Youth Programme or Youth Advisory Board. Major London galleries such as the Tate, ICA and National Portrait Gallery all have Youth Teams which you may be eligible to join to enable you to actively work in a gallery setting while still a student. Not only will this expand your knowledge of art, you will also gain in-depth knowledge of how a gallery functions, be involved in devising and delivering arts programmes and events, make new friends and connections from an arts environment and also gain an impressive addition for your CV. It will alert you to the wide variety of careers in the Arts sector and give you the confidence to network with industry professionals. During your school and university holidays, consider working in a gallery setting or a creative field you find interesting so that you can begin to consider which field of the creative sector you may wish to make a career in.

'Take a look at this website for details on jobs listings, internship opportunities, temporary work and recruitment agencies for students and recent graduates: www.ypalondon.co.uk/resources.

'Many students leave university with little real work experience, wondering how to fill their empty CV. Even a few days' work here and there is better than nothing, as employers will be looking for evidence of commitment, motivation and ambition in the current competitive arts climate. In addition to gaining some work experience, try and get involved in activities at your university itself, such as the students' union, college magazine, socials and Student Ambassador programmes. All of these are great to add to

your CV as they show an interest in your subject and evidence of communication skills and willingness to be part of a team. Try and involve yourself in these activities early on, preferably in your first year, before the pressure of exams or degree shows kicks in. Even if you are set on a career as an artist, you may need to support yourself until your own career becomes profitable, so involving yourself in these and seizing the opportunities provided at university is never wasted and may provide another string to your bow.'

Jessye Bloomfield
Fine Art graduate, Courtauld Institute

Advice when choosing internships:

- *'Aim for at least three months so that you have enough time to get to know a company.*
- *Try and find somewhere that pays travel expenses / lunch expenses, as you will not be paid a salary.*
- *Really research the company you want to intern for and find blogs where previous interns talk about what they did there and what they learnt. I know many people who saved up money to intern in London and then ended up making coffee for three months and learnt nothing.*
- *Speak with your tutors about the best places to intern as they may have a contact there or have sent students there in the past and can let you know what to expect – my tutor's advice was not to apply to certain companies due to previous bad experiences of past students.*
- *When interning, if you're not gaining experience in the area you want to be, you need to speak up – for example if they put you to assist the pattern-cutter but you want to be assisting the print designer – which is actually really nerve wracking, but important.*
- *If you work for a small company you will gain experience in all areas and get a much more hands-on approach, but if you work for a larger company you may get to do less but you may have a better chance of getting a job with them after you graduate.*
- *Be as niche as possible – if you want to get into menswear and love digital print, find a company that specialises in digitally printed men's shirts.'*

Annabel Knowles, BA Fashion graduate

2 | Foundation courses

Art and design Foundation courses – the full name is Level 3 Diploma in Foundation Studies (Art and Design) – provide a bridge between the kind of study undertaken at GCSE and A level and the type of work you will do on courses offered at degree level. Although there are exceptions, for those of you currently studying general A levels and hoping to get into art school, taking up a place on a Foundation course will be your next step. Most typically, they are self-contained one-year courses available at a variety of different types of institution, including universities, art schools and colleges of further and higher education.

Why do you need to do a Foundation course?

If you have not completed an Applied A level or a BTEC National Diploma in Art and Design, a Foundation course will give you an opportunity to find out much more about your creative interests and abilities. You will have the chance to experiment with methods and materials that may not have been previously available to you. You will have the freedom to explore your own ideas and will be truly working for yourself.

What can you expect from a Foundation course?

You can expect to have a lot of fun. While each course will have its own individual style, and while content may vary, all Foundation courses will attempt to challenge and develop your critical awareness and creative skills. They will help you to select a specialist area of study, prepare your portfolio and make applications for degree courses. There is probably no better way to prepare for a specialist degree course than by completing Foundation studies. Take a look at the views of these students.

> 'The Foundation course taught me so many practical things – I don't mean creative techniques, but about how to cope at art school and be successful. When I first arrived, two things surprised me. The first was that my teachers gave me ideas and projects to do, but didn't really "teach" me in the way I had expected. This was unnerving at first but gradually I realised that the ideas and creativity had to come from me – they were there to guide me. The second thing I quickly realised was how ambitious and focused my fellow students were, how they fought for work space, time in the studios and attention from the teachers. So I had to do the same. I think it was this that sorted out the truly serious students from those

that wanted an enjoyable university experience but did not have a burning desire to become an artist.'

Miki Lee, Central St Martins Foundation course student

'When I first thought about studying art at university, I was pretty sure that I wanted to go down the fine art route and I was slightly disappointed that I needed to do a Foundation course, because, to be honest, it sounded like a bit of a waste of time. At A level I did some 3D work, photography and textiles as part of the course and the Foundation course just seemed like an extension of this, another year to get through before I could actually concentrate on painting. However, once I had been to some open days I changed my mind completely because I was able to talk to current Foundation students who had felt the same as me but were now loving the chance to experiment with many different media and techniques. As a result of the Foundation course, many of them had changed direction because they had discovered where their true talents and interests lay.'

Peta Edwards, Chelsea College of Arts student

'The Foundation art course at Central St Martins has been a valuable experience to me both personally and professionally. The anxiety I felt when I started was unlike the usual nerves of "newness". It was rather like opening a new door beyond which you find a different yet interesting perspective on what you left behind. To me, the course not only helped me to understand more about myself but also to explore many new possibilities of my ability.

'I started in the general class before specialising in the "contextual practice" pathway, while others would go off to hone their skills in 2D (painting), 3D (sculpture) or 4D (film). We were great inspirations to each other, and the best thing is that the teacher allowed us to find our own limits.

'It is debatable whether appreciation should come from within or from external inspiration. The Foundation art course helped me to find my answer and motivated me in other paths that I pursued.'

Fi Dinh, Central St Martins Foundation course student

How Foundation courses are organised

Colleges vary in the ways in which they organise their courses, but in nearly all cases you will choose from the following areas of study:

- **art:** painting, sculpture and drawing; possibly also film and photography
- **communication:** graphic design, illustration and time-based media
- **design:** ceramics, metals, fashion and product design.

Course content is standardised to a certain extent, in accordance with the regulations of the five awarding bodies that validate courses in England, Wales and Northern Ireland. These are ABC Awards, Pearson, the Welsh Joint Education Committee (WJEC), the University of the

Arts London (UAL) and Ascentis*. Under their regulations, Foundation courses are divided into three phases, each phase being roughly equivalent to one of the three terms that make up the academic year.

Provider	1st stage	2nd stage	3rd stage
ABC (8 units)	See website for options (www.abcawards.co.uk)	See website for options	See website for options
Pearson (3 stages, 10 units with some optional units)	Exploratory Unit 1 Researching, Recording and Responding Unit 2 Media Experimentation Unit 3 Preparation and Progression	Pathway Unit 4 Information and Interpretation Unit 5 Personal Experimental Studies Unit 6 Extended Media Development Unit 7 Information and Interpretation Unit 8 Personal Experimental Unit 9 Extended Media Development	Confirmatory Unit 10 Final Major Project
WJEC (3 stages, 6 units)	Unit 1 Drawing as an investigative process Unit 2 Exploring materials and making	Unit 3 Developing specialist practice and preparing for progression Unit 4 Personal development and innovation	Unit 7 Preparing a major project Unit 8 Creating and exhibiting a major project
UAL (9 units grouped in 3 stages)	Unit 1 Introduction to visual language Unit 2 Introduction to research skills Unit 3 Introduction to critical and contextual awareness Unit 4 Introduction to materials, processes and technical skills	Unit 5 An integrated approach to 2D problem solving Unit 6 An integrated approach to 3D problem solving Unit 7 An integrated approach to time-based problem solving	Unit 8 Developing an art and design project Unit 9 Opportunities for progression in art and design

Sources: www.abcawards.co.uk, www.wjec.co.uk, qualifications.pearson.com, www.arts.ac.uk

*Ascentis only releases the specification to approved centres.

Table 1: Summary of Foundation course structure

The exploratory phase will give you a general introduction to the theory and practice of art and design. You will have the chance to experiment with a wide range of materials you may not have had the opportunity to use before – including plaster, wood, metal and ceramics, for example – and will work on projects designed to help you identify your strengths and interests. In the second or pathway phase you will investigate a specialist area of art and design practice, guided by a tutor experienced in that field. At this stage of the course you will also begin to put together a portfolio for degree course applications.

Last comes the confirmatory phase, during which you will complete your portfolio, work on a major project (usually negotiated with your specialist tutor) and put together an end-of-year show. The build-up to the end-of-year show and the show itself are things that you won't forget. The Foundation course exhibition might, for example, include static exhibits, multimedia displays and a fashion show.

During the final stage you will be expected to produce a personal confirmatory study or project(s).

Although the three stages are followed by all colleges, tutors have some discretion over the way in which students are taught. There are two main methods. During the exploratory phase some colleges allocate periods of time to different art and design disciplines, perhaps one week spent on drawing, followed by another on graphics, fine art, fashion, photography and so on. Others prefer to set projects lasting several weeks, which require students to work in several disciplines at the same time.

Students often fall into the trap of assuming that Foundation courses are totally practical. They are not. At least half a day a week will be spent on contextual studies, including the history of art and design, and you will be expected to produce written assignments, including the creation of a personal statement (sometimes known as a statement of intent) that outlines your final major project.

Another common mistake is to think that studying on a Foundation course will be rather like being at school, with free periods during the day. Foundation course students work hard! Most courses will run from Monday to Friday, often from 9.30 a.m. to 4.30 p.m. or later. You can also expect to attend at least one evening class a week. Your working week will be divided into studio practice, lectures and seminars, visits and personal study time.

Although there are exceptions, Foundation courses often have very large numbers of students, sometimes as many as 400 all following the same programme of study. For people used to small class sizes, this prospect can be daunting. In practice, nearly all students find that they quickly adjust to their new working environment. Many students find that they really feed off the hustle and bustle that comes with working in large groups, and, in part, the course will be about learning to work with others.

Here are some other characteristics of a Foundation course.

- Do not expect lecturers to spend too much time chasing you up. Making the most of the course will be your responsibility. It will be up to you to attend.
- You will find yourself involved in group projects and can expect to forge strong friendships with your fellow students.
- The course will be exhausting at times but it will also be very exciting.

The view of the student set out below should give you more of an idea of what to expect.

'During the first part of my course at Loughborough I have been in the studio four times a week. The main difference I have found on the Foundation course compared to A Levels is that there is no requirement to complete a set project over a term in a sketchbook. Instead, I am set a project to complete on A2 sheets to be completed in a day or over a couple of days. Alongside this, I have to maintain a sketchbook to include sketches, processes, ideas, notes, details of artists linking to my project. I have preferred this shortened, focused format compared to A Levels.

The facilities at Loughborough compared to what I have used before are incredible. There are a huge range of areas to choose from which allows you to experiment. Next week I start a taster session in my chosen pathway hub for me to specify in later weeks of the course.'

Keiran Wye, Foundation, Loughborough University

Choosing a Foundation course

Getting started

Even though Foundation courses now have a national framework, this may be interpreted very differently by different art schools and colleges, and what suits one student will not be right for another. You can do an initial search on the internet. Have a look at the websites listed in Appendix 1 – the great thing about art schools' and colleges' websites is that they are extremely creative and entertaining. You can spend many happy hours investigating them. They are updated and changed on a regular basis, and, at the time of writing, particularly good examples include the University of the Arts London (www.arts.ac.uk), Edinburgh College of Art (www.eca.ed.ac.uk), Norwich University of the Arts (www.nua.ac.uk), Falmouth University (www.falmouth.ac.uk/falmouth-school-of-art), Glasgow School of Art (www.gsa.ac.uk), the Architectural Association School of Architecture (www.aaschool.ac.uk) and Winchester School of Art (www.southampton.ac.uk/wsa).

Next, get hold of as many prospectuses as you can and read them carefully. Do not just look at the pictures, but read about the course

structure. If you love photography and this does not seem to feature at a college you are considering, you ought to think twice about applying there.

> '*I chose Bournemouth for my Foundation because I enjoyed the interview, and because I wanted to be in an art campus as I thought I would prefer being in a creative atmosphere. The tutor was encouraging and I wanted somewhere with a drawing programme as mine was atrocious. I knew I wanted to study fashion for my degree so the Foundation was a bit frustrating at times as we spent a week on graphics, a week on fashion, etc. But in retrospect, the skills I learnt doing this were really useful later on in my degree.*'
>
> Annabel Knowles, Arts University Bournemouth

Course content

Look very carefully at exactly what you will be able to study. Consider the course content: Is it well structured? Is it flexible enough to allow for personal input? What about the range of subjects covered – is there a wide variety? Although Foundation courses are designed to allow you to gain experience across a whole range of disciplines, they do differ from college to college, and so it is important for you to choose a course that suits your needs. If your aim is to study fashion design at degree level, for example, then you will need to spend at least some of your time specialising in this area of study, so make sure that it is properly catered for.

Location

You can apply anywhere in the country for your Foundation course. However, the majority of students choose somewhere close to home, mostly for practical reasons. These include issues such as accommodation and living expenses, and the reassurance of knowing other people who are at (or have been at) the college. Accommodation, food, travel and materials can be very expensive, and this is a particular issue of concern because a Foundation course is classified as further rather than higher education and you will not be eligible for a student loan. However, UK and EU students under 19 years old are not charged tuition fees in further education. (For further information on funding, see Chapter 10.) This is worth remembering, considering the amount you will have to pay for your subsequent course.

It is also worth bearing in mind that Foundation courses are very demanding in terms of time and energy. It is often hard to combine a Foundation course with a part-time job. However, many students do choose to move away from their local area, either because the local college (if there is one) does not suit their preferences or because they are excited about moving to a new environment.

'Year Zero' courses

In Scotland, the usual system is for degree courses in art and design to be four years in length, with the first year being a diagnostic course – the equivalent of a Foundation course. Several institutions elsewhere in the UK are now also offering this pattern. If you like the idea of continuity – not moving to a different university or college after your first year – you might like to look at this option. There are important funding implications, though. Year Zero students are enrolled on higher education programmes – which makes them liable for tuition fees. You can find further information on funding in Chapter 10.

Facilities

Questions you may wish to consider include the following:

- How big are the studios?
- Is the light good?
- What are the IT facilities like?
- Does the college have a well-equipped workshop in which you can experiment with a wide variety of materials?
- Is there a photographic darkroom and studio?
- Will you have access to a ceramics studio?
- What is the library like?
- Is there a wide range of books?
- Does it have a good multimedia section?
- Will you have to pay studio fees, and if so what will they be? (See page 32 for further information on studio fees.)

You should also think about other issues: what are the communal facilities (such as refectories, bars and social areas) like? Some colleges are attached to universities and so you might be able to use their facilities as well. However, this might also mean that the social facilities are not on-site and so some travelling may be necessary.

You will be able to answer some of these questions once you have read the prospectus or looked at the website, but many questions can only be answered by making a visit.

Open days, visits and speaker evenings

It is vital to attend open days or, if this is not possible because the dates clash with other commitments, to arrange a private visit. The facilities and atmosphere of an art college are the key to whether you will be able to flourish there. Whatever the website says, you will only know whether a particular place is right for you by visiting it. Try to talk to current or ex-students to see what they think of the place. Look at the work that has been produced. Does it excite you? Have a good look at the studios.

Check out the facilities – are they really as good as they sound? See if the students are working; a successful studio is one in which people are working effectively – is that the case?

Many schools and sixth-form colleges organise speaker evenings and other special events in which lecturers, course directors and admissions tutors from local art schools, ex-students and other specialists are invited to talk about what to expect when you study art at institutions of further and higher education. Your local college may also offer a talk as part of its open day. Make sure that you go! Information straight from the horse's mouth can be extremely useful: you get the opportunity to evaluate not only what is being said but also who is saying it and how. Most visiting speakers will try to give you a flavour of the kind of work that you can expect to be involved with. Speakers are usually happy to answer your questions, and they may show you slides or a PowerPoint display to give you an overview of what is on offer. These seminars are extremely useful and are not to be missed.

Atmosphere

Visiting the college is so important because it is the only way to get a feel for its atmosphere. Most people who enjoy art find that the particular qualities of the physical environment and the ambience of the workspace are vital to their creative processes. This varies from person to person, so you will not find league tables ranking colleges in the order of the inspirational effect that they have on their students. Some people like a buzz around them – lots of noise, activity and excitement; others prefer a quieter, more contemplative environment.

How will you know which colleges are right for you? The only way is by visiting them and talking to students who are studying there. Never choose a college solely because someone else, such as a teacher or a parent, says that it would be right for you. Trust your own instincts about whether or not the atmosphere feels right. You are the one who will have to work there!

Making the final selection

Using the categories above will have helped you to narrow your choice down to a handful of institutions. It is sometimes helpful to rank your shortlist in terms of location, facilities, the course, atmosphere, etc. You could give the top college in each category five points, the second four points, and so on. Once you have added up the scores, hopefully some clear winners will emerge. The important thing at this stage is to be honest with yourself about how the colleges match up to your requirements. If a college does not fulfil your needs, then even if going there 'feels' great it will not be. Make sure that you stick to the criteria and try to

establish a clear winner based on the facts. You may well find that a couple of colleges are equally suitable and, at that point, gut feeling may help you to make your decision; but as a general guide, stick to facts and not fiction. In other words, do not believe the hype.

Working with your teachers

The final decision on where to go will be yours, but from time to time we can all benefit from a little guidance. Make sure that you work with your teachers. Talk to them. Ask them what they think your options might be. While no teacher is infallible, they will be able to help. Your teachers will probably have first-hand experience of local Foundation courses and will have some information about application deadlines and portfolio requirements. They will know which of the local courses are the most competitive – and whether you would be in with a chance. (Luckily, since there is no limit to the number of Foundation course applications you can make, you can still have a shot at the most difficult to enter while making one or more other applications for safety.)

It is highly likely that your art teacher will be more closely involved with your application than any other person who teaches you, so make sure that you maintain a good relationship with them and try to take full advantage of their expertise.

TIP!

Try to be organised in your preparation. You will need to create a file or folder to store all the forms and information you will receive. Make sure that you keep your diary or personal organiser up to date. If you do not use one, now is the time to start. The last thing you want to do is miss out on the chance to visit a college because you forgot the date of the open day. Do not try to keep all of this information in your head – you will not be able to remember every-thing. Before making your choice, make sure that you also read Chapter 7, 'Putting together a portfolio'.

Entry requirements

As is the case with degree course applications, each institution will have its own entrance requirements for Art Foundation courses. These will be specified on the Foundation sections of the colleges' websites. As a general guide, most courses will require:

- 5 GCSE, IGCSE (or equivalent) passes at C grade or above, including Mathematics and English;

- 1 or 2 A level (or equivalent) passes, usually with the stipulation that one is in an art, design or media subject. For Foundation courses, the requirement is normally a 'pass' (E grade at A level, or equivalent);
- A portfolio or selection of work that is uploaded to the colleges' websites and/or brought to interview.

Some colleges will set candidates a creative task which will also be used for selection. For example, Falmouth University will send all applicants a project brief and set a deadline for the work to be e-mailed or uploaded. Candidates who submit the brief will then be called for interview and asked to bring the original work with them.

Information on how to apply for Foundation courses can be found in Chapter 5.

Checklist

- Send off for prospectuses.
- Check out prospectuses, university guides, etc.
- Check out websites.
- Confirm dates for open days, visits and speaker evenings – and attend them.
- Draw up shortlists.
- Talk things through.
- Make a decision.
- Make your application.

3 | Degree courses

This chapter provides an overview of degree courses in art and design. It aims to give you a feel for what to expect at degree level and discusses aspects of how to find the right course for you. Architecture courses are dealt with in Chapter 4.

Where are you now?

By the time Foundation students begin the second term of their course, most, though not all, have a fairly good idea of the direction in which their work is heading. Having completed the exploratory phase of the course in which you experimented with a variety of materials and methods across a broad range of disciplines, you will have chosen a specialist area of study such as fashion, textiles, painting, illustration or product design. By this point you will have begun the process of putting together a portfolio and will be considering your options at degree level. Alternatively, you may be an Applied A level or diploma student in your second year of study.

In both cases, you will have begun to specialise in a particular area of art and design practice and will be considering your options at degree level. In some cases, although rarely, you will be in the A2 phase of your A levels and considering making a direct application to degree courses.

What is a degree course?

An honours degree course is a specialist programme of study offering students the chance to develop practical skills in, and experience and understanding of, a specific area of art and design. Courses offered at degree level will combine practice with theory and, as such, most will require you to undertake some form of contextual studies alongside your practical work. This will vary from institution to institution and may consist of a formally presented illustrated dissertation or some type of multimedia presentation. All courses will show you how to operate within your chosen area of study at a highly sophisticated level. Applications to most degree courses are made through the UCAS system.

Higher National Diploma (HND) courses are generally of two years' duration, and on many HND courses students have the option of transferring to the bachelor's degree (BA) course.

Honours degree courses usually last for three years. Most of them are self-validating. (This means that the institutions offering them have the power to award their own degrees.) In some cases, however, such as in smaller institutions, the degree is awarded by a university which validates the course on behalf of the college. Do not worry if an institution does not award its own degrees. Some highly respected art schools that have international reputations and recruit students from all over the world do not do so. The college's website will give details of the accrediting university.

Although there are exceptions, within the field of art and design there are three broad areas of study available at degree level:

- fine art
- visual communications and design
- the applied arts.

It is from these three disciplines that you will select a specialist area of study.

Specialisations found within the areas of visual communications and design or the applied arts typically aim to prepare you for the workplace and, in that sense, may be highly vocational in nature. Sometimes they will include a period of work experience. Courses based on fine art, such as painting or sculpture, will be more geared to professional studio practice (although your creative skills may also be valued by industry).

There are essentially four different types of degree you can choose to take: single or joint honours, or a modular or sandwich degree.

Single honours

Most art and design students studying at degree level in the UK follow a single honours course. Competition for places at well-known universities and colleges is strong. You have to compete to get on a degree course, as there are more applicants than places. Applications for 2014 entry were up by around 3% on the previous year, and the success rate for applicants for design or fine art courses is around 70%. UK students took most of the places (around 50,000), with international students taking another 5,000 places. The international students were split evenly between EU and non-EU. (www.ucas.com)

Courses at colleges with international reputations (and there are many) attract enormous numbers of applications. Places at these institutions are as hard won as for any other type of undergraduate study. Courses typically run for three years and will require you to complete some form of moderated study of the history of art and design. You will have to pass this element of the course in order to be awarded your degree.

Joint honours

These courses make it possible to combine the study of distinct but often complementary subjects, for example art and psychology at Reading University.

Modular degrees

These courses enable students with a wide range of interests, including those outside the field of art and design, to combine the study of a variety of subjects. At the University of Chester, for example, fine art can be studied in combination with English literature.

Sandwich degrees

These may be any of the course types mentioned above, but will also contain some form of structured work experience. Most typically this will take the form of a 'year out' beginning at the end of the second year, in which you will work in industry, returning to complete your studies in the fourth and final year. This will normally be arranged by the university.

A year abroad

Some courses provide an opportunity for students to spend a period of time studying overseas. For example, the University of Leeds offers four-year international or European fine art programmes that include up to a year of overseas study in Europe or North America. For further details, you should look at the college or university websites.

What can you expect from a degree course?

Because you will be studying for three years or more and will be concentrating your efforts in a specific area of art and design, on a degree course you can expect to develop high levels of expertise. Degree courses should offer you excellent facilities and technical support within your chosen area and will also provide you with access to resources outside your specialisation, often by means of reciprocal arrangements with other institutions. You will be asked to consider issues and ideas at their most fundamental level and encouraged to fully realise your creative potential. You can expect to enjoy the full range of extracurricular activities that are available to all undergraduates.

Entry requirements

- The Course Search facility on the UCAS website provides links to all degree courses, and includes information on entry requirements. This will be given in terms of A level grades, International Baccalaureate, Scottish Highers and most recognised international qualifications.

Entry requirements may also be given as a score on the UCAS Tariff – a system of allocating points to academic qualifications. However, for almost all creative courses, a portfolio of work will be the main means of assessment. The university or college will specify that: 'for the first year entry of this course you will be assessed by portfolio/ evidence'.

● Information on the UCAS Tariff can be found at www.ucas.com/ ucas/undergraduate/getting-started/entry-requirements/tariff/.

● The UCAS Tariff will be changing for courses starting from September 2017. Details can be found at the above link.

Degree course specialisations

There is an enormously wide variety of specialist courses available at degree level (see Figure 3). Some disciplines will be familiar to you, others will be entirely new.

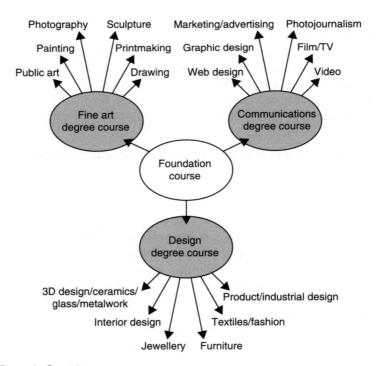

Figure 3: Specialist courses

The following pages list some of the courses available.

Taking the three general areas of study already mentioned as a starting point, the following lists are designed to give an overview of some of the

courses available. These lists are not definitive – new courses are being set up every year. Please note that some specialist areas of study appear in more than one list. This is because a subject such as photography, for example, could be studied in the context of fine art, with an emphasis placed on personal self-expression, or might be offered as a visual communications course if it concentrates on preparing you for a career in photojournalism.

Fine art

These courses, which place an emphasis on personal creativity and self-expression, can cover a wide variety of disciplines and often include:

- drawing
- painting
- photography
- printmaking
- sculpture
- tapestry
- textiles.

Visual communications

These courses are typically vocational and can sometimes include a period of work experience:

- advertising
- advertising and editorial photography
- animation
- biological imaging
- corporate identity
- film and television
- forensic photography
- graphic design
- graphic design and advertising
- illustration
- lettering
- photography
- print and graphic communication
- public art
- typographic design
- visual communication design
- wildlife illustration.

Design and the applied arts

Again, these courses are usually vocational in nature and often aim to prepare students for professional practice:

- architectural glass
- ceramics
- conservation
- fashion
- fashion design with technology
- furniture
- glass
- interior design
- interior textiles and floor coverings
- jewellery
- knitwear design
- museum and exhibition design
- performance costume
- product design

- silversmithing
- swimwear
- textiles
- theatre: designing for performance
- transport design.

Foundation degrees

So far, we have been talking about honours degrees, but there is another type of degree course available that you might like to consider.

Foundation degrees have been available since 2001 and are on offer in a wide range of subjects. The title is a little unfortunate since they could easily be confused with Foundation courses! The new courses are a qualification in their own right and can also lead on to an honours degree course. Designed in consultation with employers, they are courses that train people in specialist career areas and develop:

- work skills relevant to a particular careers area
- key skills, for example communication and problem-solving
- general skills, such as reasoning and professionalism.

If you do a Foundation degree you will be able to choose between entering employment and continuing training in your job, or converting the qualification into an honours degree through further study, usually by transfer into the second or third year of a related degree course. Foundation degrees are available in a range of disciplines including graphics, fashion, interior design, three-dimensional design and digital media design. A full list of courses and more information can be found in the Foundation degree section on the UCAS website (www.ucas.com).

Finding the right course

Most students applying for places on specialist degree courses either are attending or have been to art school. Perhaps you have been studying close to home and want to move further afield, or perhaps you are well established where you are. You may have a pretty good idea of what you are looking for, but try to keep an open mind. Do your home-work. Get hold of as many prospectuses as you can and read them carefully. Don't just look at the pictures; read about the course structure and content. If you plan to study furniture design, for example, and love to make things in the workshop, make sure that the courses you are considering are supportive of this approach. Use the internet – the great thing about art schools' and colleges' websites is that they are extremely creative and entertaining. Information on how to apply for undergraduate courses can be found in Chapter 5.

Course content

How will you know which course is going to suit you? For example, what is the difference between studying a BA in Glass and a BA in Architectural Glass? Degree courses in specific subjects will differ from college to college. Some illustration courses, for instance, will place more emphasis on digital manipulation while others will focus more on traditional drawing techniques – so it is important for you to understand exactly what is being offered.

Take full advantage of the literature available. Make sure that you read and fully comprehend the course specification. If you are unclear about anything, try to speak to the course director or head of school. Look very carefully at exactly what will be studied, at what point in the course and for how long, and how much flexibility and choice you will have. For example, if you want to become a forensic photographer, make sure that you are not applying to a fine art photography course!

Since many art and design graduates work freelance, it is important for them to understand how to run their own business – about finding premises to work in, tax and legal requirements, and how to calculate costs when pricing their work – and how to market their work and present it to prospective employers or buyers. If you think you may freelance in the future, ask now whether the course contains modules on self-employment, given either by course tutors or by the college or university careers service.

Location

You can apply anywhere in the country for your degree course. Consider the practicalities, such as the cost of accommodation and travel. Moving to a big city may be attractive, but will you be able to afford it? Many students enjoy and benefit from the dynamism that city life can offer; some prefer to live and work in a quieter location. What will be right for you? For many students it is essential that they are close to galleries and museums. What are the local facilities like? Do they meet your needs? Higher education is expensive and, although you may get some financial help, nearly all students have to raise funds privately. If you are planning to work part time, are there job opportunities?

> 'Firstly, I would never have thought of changing my career if I had not come to London. Many short courses were available at the time I came to London and therefore it was very easy to start something new. You are also encouraged to study further if you are enthusiastic about the subject. From a practical point of view, there is a great deal of cultural diversity co-existing in London. It helped me clarify my own cultural identity and aesthetics, what I see as beauty,

as well as learning from other cultures. The Western way of seeing things seemed to conflict with my idea of beauty. However, in the latter stages it helped me develop my own visual language and learn how to convince people how and why I see things in my own very specific way.'

Akiko Hirai, ceramicist

Facilities

Does the college have the facilities that you will need to study your subject? A degree-course studio should be very well equipped. Make sure that the relevant technology is up to date and kept that way. As well as working within your own field you may well need to cross over into other areas of art and design. Many art schools have reciprocal arrangements with other institutions. Do these exist and will they be practical? If, for example, you intend to study sculpture, you will no doubt be looking for spacious, well-lit and well-equipped studios, but what about the IT facilities? Remember that you will have to put together some kind of contextual study. Are the computers up to the job and could you use them to create 'virtual' sculpture?

As your skills develop, so will your needs. Try asking yourself the question: 'Do I know what all the equipment is for?' If you do, then the course is probably not well equipped.

You should also think about communal facilities such as refectories, bars and social areas. Some colleges are attached to universities, and so you might be able to use their facilities as well. However, this might also mean that the social facilities are not on-site and so some travelling may be necessary.

Student support

Does the institution provide good welfare arrangements, such as student counsellors and an accommodation office?

Studio fees

Most institutions charge students studio fees. These can vary considerably from place to place, and, although they are not likely to influence your final decision when compared with other factors, it is worth finding out what they are and what facilities you get for the money. (This is not something that is usually quoted in prospectuses or course leaflets.) 'Studio fees' is a bit of a misnomer since it sometimes also includes course materials. It is also worth enquiring about the price of materials sold in the university or college shop, if this is the system that applies. You could also check – perhaps by asking a student on an open day –

whether the final degree show involves students in much expenditure. You will be able to answer some of these questions once you have read the prospectus or looked at the website, but many questions can be answered only by making a visit.

Open days and visits

It is only by visiting a course that you will get a feel for its atmosphere. Most artists and designers find that the physical environment and the ambience of the workspace are vital to their creative processes. This varies from person to person, so you will not find league tables ranking colleges in the order of the inspirational effect they have on their students. But ask yourself: 'What is the vibe like?' It might suit other people, but will it suit you? Make a point of talking to students who are studying there. Is the working environment a productive one? Can you picture yourself in it? Never choose a college solely because someone else says that it would be right for you. Trust your own instincts about whether or not the atmosphere feels right. After all, you are the one who is going to study there!

Past students

It is always interesting to look at the names of practising artists who have graduated from the university or art school. Although famous alumni do not necessarily make one institution better than another, they can act as a guide to the type of work that is being undertaken there. And if an artist you really admire studied on one of the courses you are investigating, this can add to the attraction of the college.

The final choice

Remember that you are going to have to live with this decision for three or four years, so try not to be carried away by a sudden rush of blood to the head. As important as it is to trust your instincts, using the steps outlined above to narrow down your choice to a handful of institutions will help you make a decision you won't regret.

Go through this list and think things over carefully. Talk things through with the people who know you best – you will benefit from a second opinion. Rank your shortlist in terms of location, facilities, the course, atmosphere, etc. Try giving the top course in each category five points, the second four points, and so on. Use the scores to help identify which course meets your requirements. You will probably find that there are two or three courses that are up there. Don't be afraid to trust your instincts, but make sure that your shortlist is based in reality and not fantasy. Read the lecturer's view below on making that final choice.

'When prospective students are considering Lincoln I would always suggest that they visit on an open day if possible or make an appointment with the programme leader if they can't make an open day. You cannot decide from a website or a prospectus. I would also suggest that they should meet a current student on their chosen programme. A student will be able to answer those awkward questions that might be difficult to ask at an interview and will also give an honest feel for the place. This is especially true for mature candidates who might be a little unsure about returning to higher education. Mature students are always happy to share their experiences.'

Dr Mary O'Neill, Senior Lecturer in Cultural Context, Higher Education Academy Teaching Fellow, Faculty of Art, Architecture and Design, University of Lincoln

'When applying for a BA, I think it is important to realise that it is just as much you interviewing them as they are interviewing you. BA level is no longer compulsory education, but is an opportunity to further your knowledge in something you are passionate about.

'The difference between BA and A level is largely the need for independent research and self-motivation. Varying from course to course, you can expect to be educated in both technical and conceptual skills, but it is down to you to take this information and turn it into something. After doing my Foundation I am now in my second year of a photography degree at Leeds College of Art. I see a degree as a personal investment, so, to make sure I picked the best place suited to my needs, I wrote a list of key questions to ask each university during interview. These included enquiring about their facilities, was it a "vocational" or an "academic" course, the student–teacher ratio (having a personal teaching experience may be something that's important for you), whether they allow cross-disciplinary collaborations, trips and relationships abroad, whether the briefs are set or self-devised, and how the course is structured into modules.

'The BA requires you to work for yourself rather than for a teacher. You must be passionate about the subject you choose, as self-motivation is crucial in order to succeed and to make it as personally fulfilling as possible.'

Rosa Nico de Graaf, BA Photography student, Leeds College of Art

'The idea of going overseas to study is daunting, yet it's a new chapter in my life. I was sure I wanted to study photography overseas. Through UCAS and university fairs, I got to meet international officers from a wide range of schools in America and England. I can still remember walking up to the booth for Falmouth

University, showing my portfolio and seeing pictures of the campus and getting some general information.

'A couple of weeks later, I visited England for a week to visit my top five university choices. I went to Falmouth University and met one of the professors and the course leader of the BA (Hons) Photography course. I showed the course leader my portfolio and talked about how the course was taught and how I got into photography. It was scary as the course leader would be the one who would decide if I was accepted onto the course or not. The only thing that kept me calm was that I didn't know it was an interview – I assumed it was more of a question and answer session. It was really great to meet someone who had the same interest as I did but I was a little nervous.

'I was very glad I got the opportunity to visit the university as it was a key part of the final decision process.'

Justin Lee (Hong Kong), BA (Hons)
Photography, Falmouth University

Checklist

- Send off for prospectuses.
- Check out prospectuses, university guides, etc.
- Check out websites.
- Confirm dates for open days, visits and speaker evenings – and attend them.
- Talk to tutors.
- Draw up shortlists.
- Talk things through.
- Make a decision.
- Make your application.

4 | Architecture

There are a number of possible routes for students who wish to apply for architecture courses. Applications for some courses, such as those offered by art colleges, are made in the same way as for other art and design courses; but you can also apply to study architecture at UCAS institutions without the need to do a Foundation course, or at private institutions. These routes are described in this chapter.

Of all the different manifestations of art and design that we encounter in our daily lives, the work of architects is, along with that of clothes and product designers, the one that people come into contact with most often. Every shop, office building, fast-food outlet, cinema, coffee shop, bridge or multi-storey car park that you see on your way to school or work has been designed by an architect. The work of some architects is immediately recognisable. London's 'Gherkin' and The Shard, the Pompidou Centre, or Frank Gehry's Guggenheim museum in Bilbao spring to mind. But your house or flat was also designed by an architect, as was your train or bus station.

To practise as an architect in the UK you need to gain registration with the Architects Registration Board (ARB). This takes a minimum of seven years after you leave school. But don't be put off by this if you are interested in architecture because this does not mean that you will spend seven years in lectures; although you will have to attend some lectures, the seven years involve a combination of academic study and work experience in an architectural practice. If you are interested in architecture and want a shorter course so that you can work within the fields of architecture or related subjects such as interior design, then there are other, shorter options available. This chapter will explain the different routes available to you.

Qualifying as an architect

Registration with the ARB

In order to gain registration with the ARB, you need to pass three stages, which are overseen by the Royal Institute of British Architects (RIBA – incidentally, if you are serious about becoming an architect, try to visit the RIBA's London headquarters, which holds many exhibitions as well as being home to an impressive architecture bookshop). A typical route to gaining registration is shown in Table 2.

Year	Programme	Stage in the RIBA process
1 2 3	Bachelor's degree in architecture – BA, BArch, BSc or equivalent (see below)	Part 1
4	Work experience	
5 6	Postgraduate study – Dip Arch, MArch or equivalent	Part 2
7	Work experience	Part 3

Table 2: Typical registration route

Choosing a course

If you are going to embark on the journey towards becoming an architect, you need to think carefully about the first three years of the course. There are a number of options and the right one for you will depend very much on your academic and creative strengths. There are about 45 universities in the UK that offer three- or four-year undergraduate degrees in architecture (usually UCAS code K100 or K101) that will give you exemption from RIBA Part 1. There is a section on the RIBA website that lists these institutions (see Chapter 12). Some of these are more geared towards students who are interested in the structural as well as the creative aspects of architecture, and these often require A levels in Mathematics and/or Physics.

Other universities concentrate more on the creative aspects of architecture and so require A level in Art. In some cases, history of art can be an advantage if the course has a significant focus on the historical side of architecture. You will often hear people talking about 'the language of architecture'; in the same way that there are rules – which of course can be broken – governing the construction of sentences when we speak English, architects use architectural elements in the design of buildings. Some of these are new, but often they are based on historical ideas. Just as we mix old and new words in a sentence, architects can mix old and new architectural details in a building. For entry onto these courses, you will be judged on your portfolio as well as on your academic achievements or predictions.

If you are reading this before choosing your A level (or equivalent) subjects, then spend some time looking at the entrance requirements of university architecture courses to ensure that you will have the right subjects to apply for the type of course that will suit you best. If you are already studying A levels, then you still need to do this research to ensure that you do not waste choices on your UCAS application. The UCAS website 'Course Search' facility is a good starting place, as the list of K100/K101 architecture courses has links through to the universities' entrance requirements. If you are already studying A levels and you are not doing the right subjects for an application to study architecture, you have two options.

- Take an extra year on your A levels, and add the necessary subjects. Some further education colleges and a number of independent sixth form colleges will offer a fast-track one year A level programme.
- Think about following an Access course or an art Foundation course. The universities will be able to advise you on what alternatives to A levels they might be prepared to accept.

Entry requirements

When looking at entry requirements for architecture courses, you should be aware that while these will specify particular grades or scores at A level, International Baccalaureate, Scottish Highers or international qualifications, the universities will also be looking at:

- Is the candidate genuinely interested in, and suitable for, architecture?
- Is the candidate doing the right subjects?

Some universities will also set an additional entrance test or creative task in order to assess the applicant's creativity.

> **WARNING!**
>
> Do not assume that if a university requires, for example, AAA at A level and you are confident of achieving these grades, this guarantees a place. You would first have to get an offer of a place (either conditional upon achieving the grades, or an unconditional offer if you have already achieved the grades).

Diploma courses

An alternative to the university route described above is offered by the Architectural Association (AA) School of Architecture in London. The AA is, as its name suggests, a specialist architecture school and it offers a Foundation course for students with a limited art background, a three-year course leading to RIBA Part 1, and diploma and master's courses for students wishing to qualify as architects or to pursue postgraduate studies in architecture.

The AA programme has multiple entry points, depending on your previous experience. Entry to either the Foundation course or the first year of the three-year course is through a combination of academic qualifications (two A levels, one of which must be in an academic subject) and portfolio. Bear in mind that the AA School is a private institution, and so the fee structure differs from that of UCAS institutions. Details on all of the above are available on the AA website (www.aaschool.ac.uk). See also Chapter 7 for more information on preparing your portfolio.

Preparation for your application

Architecture courses are oversubscribed. For the 2014 entry, according to UCAS, there were around 4,200 places available, and the success rate for applicants was around 70%; so it is important to be able to demonstrate to the admissions staff that you are a serious applicant.

For international students, the figures are even less encouraging, with only 50% of EU and non-EU international applicants gaining places. For 2014 entry, around 500 EU students and 700 non-EU international students gained places. More than any of the other courses that this book deals with, architecture applicants will benefit enormously from gaining some work experience with an architect before applying to universities. You can find lists of local architects on the RIBA website (see Chapter 12 for details).

In order to make your application as strong as possible, other things you should do prior to the application include:

- reading books on the history of architecture, and on contemporary architecture
- doing some research on the uses of, and properties of, common building materials such as glass, steel, concrete, stone, etc.
- background reading on a favourite building or structure (preferably one you have visited)
- visits to exhibitions
- keeping a small notebook with you, in which you can make notes and sketches of buildings that interest you.

And, of course, all these things will be mentioned in your UCAS personal statement. See below and Chapter 5 for more details.

Alternative architecture courses

Not everyone who has an interest in studying architecture wants to practise as an architect. There is a whole range of other careers that involve architecture, including:

- administration work in an architectural practice
- local council planning
- architectural model-making or computer-aided design
- architectural photographer
- interior design
- structural engineering
- teaching.

There are several courses other than the K100 degrees mentioned in the previous section that can lead to careers associated with architecture. For example:

- courses at art schools, such as the three-year BA in Architecture: Spaces and Objects course at Central St Martins (University of the Arts London)
- engineering-related courses, such as structural or architectural engineering
- art history courses.

Entry into courses such as the one at Central St Martins usually requires the student to have completed an art Foundation course (see Chapter 2).

The personal statement

A personal statement for entry onto an architecture course should incorporate the following sections.

- Why are you applying for architecture?
- What have you done to investigate architecture?
- How are your A levels (or equivalent) or other courses relevant?

Remember, the UCAS form is limited to 4,000 characters.

Sample personal statement 1 — Architecture application

Everyone is exposed to architecture from the moment they are born. Some take it for granted, but I realised when I was very young that I seemed to be more interested in the buildings around me than my friends were. In fact, I was often more interested in the buildings than in my friends! My favourite games involved making camps, hideouts and tree houses.

My interest in architecture brought together my two main areas of interest – aesthetic appreciation of shape and form and textures; and why things work. I have learnt to love the forms that can be created with concrete, for example, while also being fascinated by the physical properties of concrete that make it so useful in creating structures. I am a frequent visitor to London's National Theatre where I go to look at Denys Lasdun's brutalist architecture rather than the plays that are being performed inside. I chose both art and physics at A level and I think that they complement each other. Physics allows me to understand the properties of materials that an architect works with, and art allows me to develop my ideas and to think creatively. As I am sure is the case for most people, I can look at a beautiful gothic cathedral or a French château and be inspired by their beauty, or be amazed at the grace of a new addition to London's skyline. But what I find more exciting is the

design of buildings that have an industrial purpose – factories, power stations, gasometers. My favourite building is the Hoover factory on the outskirts of London, inspired by Erich Mendelsohn.

I enjoy reading about the history of architecture, particularly about how the development of new materials and techniques enabled architects to create new and exciting buildings. I recently read *Material Architecture* by John Fernandez, and was particularly interested in the way that the invention of concrete opened up new opportunities for architects to create more fluid designs, such as Le Corbusier's chapel at Ronchamp, which I visited last year. Physics has taught me more about the properties of materials and how they can be used in composites to improve strength.

My AS Art project was titled 'Contrast' and I decided to incorporate photography and 3D work. I was inspired by the industrial photos of grain silos by Bernd and Hille Becher, and also by the photographer Idriss Khan's use of multiple layers. I photographed a local factory façade and then printed multiple black and white versions on card which I then arranged in layers but irregularly aligned so that the view changed depending on where the viewer looked from.

Last summer I was able to spend three weeks working with a local construction company, Cameron Luke. I was able to shadow the in-house structural engineer and see how he took the architects' designs and worked on them to ensure that the buildings were structurally viable. One project he was working on was an extension to a local school, which was to house a new IT centre. The school wanted to make the extension use as much natural light as possible but also to be able to control the amount of light to create the best working conditions. Using a lot of glass also meant that the temperature needed to be controlled so that it was not too hot in direct sunlight and also warm in winter. He came up with a system of wooden baffles on the outside to control direct sunlight. These could be angled by a mechanical system to regulate light and temperature. The firm was very interested in green architecture and tried to use sustainable materials as well as heat exchangers and recycled materials whenever possible.

When I am not studying, I enjoy playing team sports. I am in the school football and cricket teams. This has helped me to work with others as part of a team. I am the chairman of the school Film Society and work with the committee in choosing films around a theme for each term's programme. This has allowed me to better understand how to lead a team but to also ensure that everyone's views are taken into consideration.

WARNING!

Do not copy this personal statement: it is only intended to be a guide. You might be tempted to get external help in writing the personal statement. While you should get advice from as many people as you can, you should not get someone else to write it for you. There are many websites that offer (for a fee) to prepare the personal statement for you, but you should be aware that UCAS uses sophisticated anti-plagiarism software to check each statement, and if it detects that the work is not your own, your application may be cancelled.

You will have noticed that the applicant has dropped a number of hints as to what he would like to discuss at the interview, by mentioning buildings, architects and ideas. If he is lucky, his interviewers will be interested in hearing him expand on these ideas, and so he will be able to talk about things he has already prepared. For example, he has mentioned:

- Le Corbusier
- Bernt and Hille Becher
- Idriss Khan
- Denys Lasdun
- Erich Mendelsohn
- use of materials
- industrial architecture
- the Hoover building
- green architecture
- his work experience.

Of course, in order to impress his interviewers, he would need to do a good deal of research into the things he has touched on in the personal statement. If there is one thing guaranteed to create a bad impression at the interview, it is being unable to talk about things in the personal statement.

> *'I knew that I wanted to study architecture, but I wasn't sure whether I wanted a traditional university route or something more creative. I knew that for my AA interview they would want to see my portfolio and I made sure that my A level Art and Design sketchbooks had lots of architecture in them as well as a wide range of other work to show my creative ability. I decided to base one of my final projects on a 3D piece which involved some model-making. I included a series of photos of this under construction as well as preliminary sketches in my portfolio.'*
>
> Lexie Zhao, Student at the Architectural
> Association School of Architecture

Graduate employment

The RIBA Student Destination Survey 2011 (a collaboration between RIBA and the University of Sheffield) looks at what architecture students do after they have completed Part 1. Of those that responded, 73% were in employment, and 78% of those employed were working within the field of architecture. Another 22% were involved in further studies. Architecture graduates generally seem happy that they chose to study architecture. Of those working within architecture, according to the survey, only a small number did not think that they would continue to a career predominantly within architecture.

Source: www.architecture.com

5 | How to apply

This chapter explains the procedures for applying for Foundation, degree and Higher National Diploma (HND) courses. However, before you apply, you need to do lots of preparation. If you have not already done so, you should read the relevant sections on choosing a course in Chapters 2, 3 and 4.

Foundation courses

In most cases you apply directly to the art colleges for entry to their Foundation courses, and you can apply to a number of colleges simultaneously, since there is no central application scheme. However, there are some exceptions to this. For example, if you wish to apply for a place at the University of the Arts London (Camberwell, Central St Martins, Chelsea, London College of Communication, London College of Fashion and Wimbledon) you are limited to one choice (either CCW – a joint Foundation programme offered by Camberwell, Chelsea and Wimbledon – or one of the other three colleges).

The application forms vary from college to college. All require basic details about yourself and your education, but they differ in the amount of space (if any) that you have to write about yourself and your interests – i.e. the personal statement (see page 46 for details).

Unlike the UCAS scheme for applications to degree courses (see page 46), there is not one date by which all applications must be submitted. The closing date for applications varies from college to college, and so you must do your research early and make sure that you do not miss any deadlines. The closing date for applications is often the end of January, but this is not true for all colleges, so consult the prospectus or the website well in advance.

Most Foundation course applications need to be accompanied by a reference, usually from the head teacher or head of art at your school or college. If you are a mature student or are not studying art at school, you should read the section for non-standard applicants (see page 51). Warn the person you choose to do the reference well in advance that you are going to apply, and ask them whether they are willing to act as a referee. References usually take time to write, so do not surprise your referee with a form the day before the deadline. Even if he or she does manage to write it in time, it is less likely to be full of the necessary

detail, and it will certainly not emphasise your planning and organisational skills!

Bear in mind that you are applying for a place on a practical course, and so the application form is only the starting point. The key elements of the selection process are the portfolio and/or the interview. Admissions staff will place most emphasis on evidence of high potential and creative ability. See Chapters 7 and 8 for more information. If your initial application is successful, you will be either asked to deliver (or send) your portfolio to the college so that it can be assessed by the selectors, or asked to attend an interview either at the same time as your portfolio is reviewed or later.

Degree and HND courses

If you are applying for honours degree courses, Foundation degree courses or HND courses, you normally do so using the UCAS system.

Almost all applications are made online using the UCAS Apply system. Further details can be found on the UCAS website and in the book *How to Complete Your UCAS Application* (see Chapter 12), but a brief overview of the process is given here.

Institutions indicate whether the application deadlines for their courses are 15 January at 6 p.m. or 24 March at 6 p.m. If you want to include some of the courses with the earlier deadline, you submit your application before 15 January, and then add further choices after this. In total you can choose five university courses, which can be a combination of the earlier and later deadline courses or all of one type.

Further details are available on the UCAS website, or from the institutions themselves.

The personal statement

If the colleges that you apply to require a personal statement (remember that applications submitted through UCAS always do), you need to plan this very carefully, as it will significantly affect your chances of gaining an interview or being offered a place.

Some Foundation course application forms allow you to write only a few lines to support your application, and they generally specify the information that they are looking for. For instance, the form used by Hereford College of Arts provides 18 lines and asks applicants to comment on why they believe that the course is suitable for them, why they have chosen the college and future career plans. Clearly, with so little space, your statement needs to be planned carefully. A good

response might include a list of your particular interests, but you must make sure that they match the facilities that the college has to offer – there is no point in writing too much about your love of textiles if you are applying for a Foundation course that specialises in photography and media.

Many application forms give you enough space to write 200–300 words in support of your application, and the UCAS online application form gives you 4,000 characters.

You should try to cover the following:

1 introduction: reasons for wanting to study art
2 reasons for choice of college
3 interests within art: areas of art that you enjoy, e.g. fine art, graphics
4 influences: artists who inspire you, exhibitions that you have seen
5 description of some of your own recent work
6 career plans or future areas of specialisation, if known
7 other information: interests, work experience, travel.

Sample personal statements can be found on pages 48–9. The first is for a Foundation course and is therefore specific to a particular institution. The space available in this case is approximately 300 words. The second is for a UCAS application and will be read by five different universities, so it has to be more general. Because the word limit is around 600 words, there is more room to explain about the candidate's background and future plans.

TIP!

In the first statement, the applicant has mentioned that she went to a degree show at the university. Attending open days or degree shows is important if you are to convince the admissions tutors that you are serious about your application. More information about open days is given on pages 21 and 33.

The best way to demonstrate your enthusiasm for art is to talk about your own work. This also gives the admissions staff an idea of your interests in a specific, rather than general, way. In the fifth paragraph of sample two, the applicant has mentioned some of her favourite artists. It is a good idea to try to include a contemporary artist, as you want to show the selectors that your interest in art is a developing one and that you are keen to be part of the current art scene rather than immersing yourself wholly in the past.

Sample Personal Statement 2 — Foundation course

I am studying fine art and photography at A level because after GCSE I decided that I wanted to work in advertising. I hope to take a Foundation course at the University of the Arts London and then follow a degree in graphic design. I chose UAL because I went to the BA degree shows last year and left feeling breathless with excitement at the work I saw. Studying in London will give me unlimited access to galleries and exhibitions.

For both my art and photography, the final exam pieces have the same title — 'Contrast' — and so I am able to explore this in different ways. For my art, I am doing a series of acrylic paintings of mundane subjects in muted shades, then creating colourful and vibrant frames as a contrast. I was interested in Howard Hodgkin's painted frames and Peter Beard's collaged frames and used these as inspiration. For my photography, I am contrasting the movement blur created by long exposures with fast shutter speeds to freeze motion. My model moves in the dark to get a blurred image and then a flash gun during the exposure freezes her. The images are in black and white but I hand colour them afterwards. I find the work of Roger Ballen very inspiring, and I have taken his ideas about creating a 'stage' for the subjects to perform in, and then allowing them to add props and to pose in ways of their own choosing as a starting point for my own 'Contrast' images.

In my holidays, I help out at Attic Studios, an art studio near where I live. This involves setting up materials for the artists and students, and cleaning up afterwards. But I also get to join in the classes and talk to the teachers and this has given me lots of new ideas.

Sample Personal Statement 3 — UCAS application

After A levels I chose to study Foundation with the aim of applying for photography degree courses. My aim, after graduating, is to become a fine art photographer and to exhibit (and sell!) my work across the world. I was originally interested in documentary photography through my Media Studies A level, but once I had seen how the barriers between documentary and art are blurred — for example, in the work of Ori Gersht, Paul Graham, Martin Parr, Simon Norfolk and Steve McCurry — I became excited about the prospect of telling a story through images but at the same time making the images themselves intriguing enough for people to appreciate them as artistic objects as well as a record of events.

My interest in Martin Parr led me to read his volumes on the history of photobooks, and I have been collecting photobooks ever since. During my Foundation I was able to use some of the printing and bookbinding facilities at the college to create my own books, which will form part of my final project. I am also interested in traditional photographic processes and have been experimenting with cyanotypes and liquid photographic emulsions. I love the work of Junglin Lee, who makes multiple exposures of the same image on paper that has been hand-painted with liquid emulsion. This creates a feeling of depth and also blurs detail so that the viewer can concentrate on the shapes and lines of the images.

Studying Foundation has been valuable because although I know I want to specialise in photography, I have mixed with students who want to be fashion designers, graphic designers, sculptors and film-makers; and so I have been able to get ideas from a range of perspectives. It has also taught me to study independently and to work on self-directed projects rather than rely on my teachers telling me what to do. Although I didn't expect to, I loved the two-week session we did on textiles because it made me think about textures and repeated patterns which I would like to use in my photography in the future.

I have a part-time job working with a local printing company, using Photoshop to enhance the clients' photos so that they can be used in promotional materials. This has taught me about workflow and the need for an eye for detail and an understanding of what the customer wants. At school, I volunteered at a school for disabled children, teaching them painting every Saturday. I learnt a lot about visual communication through this, as well as appreciating that everyone has their own ideas about painting or drawing and that there is no 'right' way to represent what you see or feel.

I studied Foundation at my local college, and this has allowed me to save the money I have earned. I will use it to fund a four-week trip to Japan this summer. I will use the time in Tokyo to visit the amazing photography galleries and bookshops there, and then I will travel to some of the other islands, hoping to get inspiration for future photography projects. Japanese photographers such as Sugimoto, Moriyama and Fukase (particularly his 'Ravens' project) have been a major source of inspiration for me. I am looking forward to sharing my experiences and inspirations by keeping a blog, and creating a photobook when I return.

Notice, also, that the personal statement includes details of artists that the applicants are interested in. Never drop in the names of artists or galleries/exhibitions that you have visited without giving some indication

of why they are important to you. The point of the personal statement is to demonstrate that you not only enjoy art in a practical sense, but also think about it.

> ## WARNING!
>
> Do not put things into the personal statement simply to impress the selectors. If you do get to the interview stage, you may be asked to talk about one or more of the artists or exhibitions that you have mentioned, and the surest way to be rejected is to be caught out. You might be tempted to get external help in writing the personal statement, and of course it is a good idea to get advice and feedback from teachers, your parents and anyone else who can help. You may be aware of the many websites that offer to prepare the personal statement for you, for a fee. UCAS uses anti-plagiarism software to check each statement, and you may have your application cancelled if it appears that the work is not your own.

Another key element in the personal statement should be something to lead the reader to ask you a specific question at interview for which you have prepared an outstanding answer. In the UCAS application, the applicant describes, briefly, her own work, but does not give much detail. She can be reasonably confident that, if she has an interview, she will be asked more about these pieces of work, and so she can prepare for this part of the interview in advance.

Individuality

The sample personal statements shown above are well structured and demonstrate the applicants' interest in art and what they have done to find out more. But remember that if you are applying to art schools, you are intent on following a course that requires creativity and an ability to convey what is inside your head into things that other people will relate to or want to use. So do not be afraid to be, as someone involved in admissions at one art school puts it, 'quirky' in what you put in your personal statement. If you have interesting ideas or interesting ways of demonstrating your passion for art or design, by all means use them. This could take the form of an anecdote, a quotation, an event or piece of art that inspired you, a poem, a dialogue … anything that helps you to show your creative side and where your ideas come from.

What to avoid

The personal statement is just that – a statement that reflects your interests and influences. There are some things to avoid at all costs.

- You must avoid using very general statements that say nothing about you. 'I have always been interested in art, and get great enjoyment from my work', without an explanation or description of specific areas of interest or pieces of work, will not give the selectors anything to go on.
- Writing 'I would like to come to your college because of the facilities' is too general: say which facilities and why they attract you. Bring in your own areas of interest if possible.
- Never make judgements about artists, their work or exhibitions without backing them up: 'I went to see the John Craxton exhibition at the Dorset County Museum and I liked it' is not going to impress anyone. The admissions tutors would be more won over, however, if you added 'because it was fascinating to see how his paintings and prints were influenced by lesser-known artists who lived there. Craxton had cousins who lived locally and so he was exposed to a variety of painters whose work was based around representing the landscapes around them. This inspired me to look at other British artists who also worked in the South West, including John Piper.'

Scottish art schools and colleges

As already mentioned in Chapter 2, the system in Scotland is slightly different: most degree courses are four years in length and incorporate the equivalent of a Foundation course. In some cases, students can enter the second year directly if they have undertaken a suitable Foundation or portfolio preparation course. For details, you should contact the institutions directly. In both cases, application is made through UCAS.

Non-standard applications

Not everyone who applies for Foundation courses is an A level (or equivalent) student. Similarly, some people apply for degree courses without having studied on a Foundation course. The main categories of 'non-standard' applicants are mature students (for further and higher education purposes, anyone over the age of 21) and overseas students. If you fall into one of these categories, you should make direct contact with the colleges that interest you to discuss your situation. Many applicants who are not classed as 'mature' or 'international' students but who nevertheless do not have the 'standard' qualifications for entry gain places on art courses every year. It may be because they took A levels in, for example, science subjects; or they left school at 16 and went to work. If you are in this situation, the first port of call will be the art schools, which will be able to give you advice about their particular requirements. This might involve some short courses,

evening classes, a 'pre-Foundation' course (see page 55) or other relevant preparation.

The colleges' websites and prospectuses will also contain sections aimed at you. It is important to be aware that, for all applicants, in addition to your personal qualities, the portfolio is the most important element in the application. Without a promising portfolio, you will not be offered a place. Make sure that you read Chapter 7, which offers detailed advice on this.

Mature students

You may already have either a portfolio of work that you undertook when you were at school (in which case, it will probably need updating), or perhaps a collection of pieces that you have been working on recently. It is often helpful to get guidance from art teachers, and for this reason many mature students will take evening classes, portfolio classes or Access courses before applying. (Sometimes this is best done at the college to which you intend to apply.)

Application to postgraduate courses is covered in Chapter 11.

Preparation for your application

Make sure you stand out from the others.

- Visit galleries and exhibitions on a regular basis.
- Keep a notebook and a camera/smartphone with you at all times to record things that interest you.
- Try to get your work exhibited in school exhibitions, your local library, local cafes – anywhere where people will see your work.
- Try to arrange some relevant work experience – this could be in a gallery, a museum, an art studio, or with a designer or an architect. Getting work experience in a creative field is not always easy, and you will need to use your contacts to find out what opportunities might be available and how best to approach them – use your friends, friends of friends, your friends' parents, your parents, your parents' friends, your teachers, your teachers' friends – anyone who can help!

6 | International students

Students from all over the world come to the UK to study on art or design courses. Many UK institutions are recognised internationally as being the best in the world. At the time of publication, over 5,000 overseas students gained places on art or design degree courses. Of these, about 50% were from countries outside the EU. Many of these students will have followed Foundation courses in the UK for a year. If you want to be a fashion designer, an architect or a product designer, or if you want to train to work in the creative sides of TV, film, IT or advertising, studying in the UK will give you the best possible preparation and qualifications.

For architecture courses, around 2,000 international students applied, of whom just over 1,100 were successful. On the face of it, these figures do not look encouraging, but the majority of unsuccessful international applicants fail not because they are not committed to or not suitable for a career in architecture, but simply because they are not fully aware of how to submit a successful application. Since you are reading this chapter, you have already increased your chances of success significantly!

Students who are interested in architecture may already be aware that the regulations for architectural training in the UK mean that UK architecture qualifications will allow them to work anywhere in the world. A significant proportion of the most exciting and high-profile architectural projects around the world in recent years have had an input from architects trained in the UK.

Most of the information contained in this book applies to international students as well as to home students. However, some aspects of the application procedures are different, and if you are applying to study art or design at Foundation, degree or postgraduate level you should be aware of this. The main differences are listed below:

- application deadlines
- interviews
- alternative routes
- fees (details can be found in Chapter 10)
- English language requirements.

Application deadlines

You should read the information on application routes and deadlines contained elsewhere in this book. If you are applying for a Foundation course, you should also check the individual institutions' websites because deadlines vary from college to college. In some cases, international students from non-EU countries can apply for these courses later than UK or EU students, and the dates for interviews may also be later in the year.

Interviews

In order to be offered a place to study art or design at an art college or a university, someone from that institution will need to look at examples of your work. If you live in London and you are applying to an art college in London, this process is easy: you turn up for an interview carrying your portfolio. During the interview, someone will look at your work and discuss it with you.

If you live 8,000 miles away, however, attending an interview is more of a problem. Art colleges and universities approach this in a number of ways.

- You send examples of your work by post.
- You scan your work and email it.
- You are interviewed in your own country.
- You attend an approved course either organised by, or recognised by, the university.

Some institutions, such as the University of the Arts London, run portfolio preparation courses in a number of countries, successful completion of which will result in the offer of a place. Another option is a portfolio review session: the institution will organise events throughout the world where students can bring their work to be looked at and discussed with teachers. Details of these courses and events can be found on the institutions' websites, and are also advertised locally. Under some circumstances (e.g. if you are considered to be too young for direct entry onto a Foundation course, or if your English is not sufficiently good) you may be advised to spend a year on a pre-Foundation course at a recommended school or college in the UK before proceeding to the Foundation course (see below).

Alternative routes

Most international students follow the same route as UK students to their degree or postgraduate art and design courses; that is, a one-year

Foundation course followed by a three-year BA course and then, in some cases, an MA course. Some universities, such as Norwich University of the Arts (www.nua.ac.uk), run specialist one-year International Foundation programmes to ensure that international students are fully prepared for their undergraduate degrees. Other institutions offer shorter, intensive Foundation programmes (for example, Middlesex University offers a 12-week Foundation programme; see www.mdx.ac.uk). However, because pre-university art education varies considerably in content and delivery from country to country (for instance, in the balance between technical skills and original ideas), some international students are not accepted directly onto Foundation courses. Others may have the potential to start a Foundation course but they may be too young or may not reach the required standard of English. Students in this situation may be advised by universities or art schools to spend an extra year in the UK prior to the Foundation course.

A popular route is to spend a year in a UK school or college either following an art pre-Foundation course (an art and design-related course together with, if necessary, English courses) or studying on one-year accelerated A level courses. This route would be recommended by the university or art school at the interview or portfolio review stage. Many art schools will have partner institutions that can provide these courses.

An alternative route for those international students who are too young to go directly onto an art Foundation course is to attend the International School of Creative Arts (ICSA), an independent boarding school near London, which opened in July 2009 in association with the University of the Arts London. The school provides pre-university training for British and overseas students to prepare them to enter a university course in the arts and related disciplines. In addition to two-year A level courses in a range of art and design subjects (with the option of adding academic subjects in combination with these), the school also offers a two-year portfolio programme, designed for those who possess the academic qualifications for university entrance but need to develop a portfolio. It also offers a fast-track Foundation programme. Further information can be found on the school's website (www.isca.uk.com).

Your portfolio

Robert Green, previously Manager of International Student Support at the University of the Arts London, gives advice about portfolios below (see Chapter 7 for more about portfolios).

The majority of our courses at the University of the Arts London are studio/practice-focused and as such entry is generally based

on portfolio assessment and interview. Therefore, careful preparation and selection of the portfolio is an essential preliminary to the interview.

The portfolio is a visual diary. It is the documentation of the individual's journey, both perceptually and conceptually, over a period of time. In essence the portfolio should be comprehensive, demonstrating a breadth and depth of inquiry, curiosity and genuine investigation. Solid practical skills and experience of working with a variety of media and techniques are, in addition, of equal importance.

The portfolio should include work done in school or college and at home. The range of approaches and the materials used should show that the applicant has made the most of the opportunities around them, in terms both of what they are being taught and the art room or studio facilities that are available. We particularly look for evidence that an applicant has been prepared to develop some ideas further on their own initiative and in their own time.

Time and care are needed in selecting the portfolio, and systematic decisions about what to include and how to organise and present the work should be made. Obvious repetition should be avoided, as should over-selection. A limited number of relevant works in progress may be included because, first and foremost, we are looking for potential.

Ideally, a portfolio should consist of between 25 and 50 pieces of recent work, completed over a two-year period. This collection of work should show evidence of a broad-based creativity and include sketchbooks, visual research books, idea sheets and any experiments or explorations in three dimensions. The portfolio should demonstrate, through project and thematically based work, evidence of individual creativity and the development of ideas. Generally, it is important that work reflects and demonstrates creative thinking and a personal commitment to a particular project.

In the early stages of all our courses we concentrate on combining technical workshops with set projects. As courses progress, assignments generally become more wide-ranging and contextually based. All practical work is undertaken within a framework of individual and group tutorials as well as studio criticism sessions, where all students are encouraged to offer constructive critical opinions and advice to each other. Critical exchange and dialogue is central to our teaching approach.

Therefore, at interview all applicants are expected to discuss and evaluate the development and context of their work so as to demonstrate broad understanding and an ability to think critically.

A portfolio does not supplement an interview, but is the main factor in assessing a student's future potential. Thus the portfolio is even more essential to students who are unable to be interviewed.

You should present your portfolio in the form of colour photographs, colour photocopies, slides or CD. It is best not to send originals in the post. You should send between 25 and 50 pieces of work. The portfolio should ideally be approximately A4 size if being sent by post.

The University of the Arts London has representatives in a number of countries across the world. Our representatives can assist with all aspects of the application procedure, offer information about programmes and courses and assist with immigration matters.

When our senior academics make their next scheduled visit, a local representative can arrange for applicants to have an interview or an advice session with an academic. Our contact details and an overseas schedule can be found on our website.

English language requirements

You should refer to the individual institutions for their requirements. To give you an idea of what level of English is required, the University of the Arts London asks:

- Fashion portfolio: IELTS 4.5
- Foundation studies, diploma, Access and ABC diploma courses: IELTS 5.0
- Foundation degree: IELTS 6.0
- Bachelor of Arts, postgraduate certificate and postgraduate diploma: IELTS 6.5
- Master of Arts: IELTS 7.0.

Information on IELTS (International English Language Testing System), TOEFL test and other accepted English language qualifications can be found on the UK Council for International Student Affairs (UKCISA) website – details in Chapter 12.

Visas

For many international students, a visa is necessary to be able to study in the UK. The type of visa and the English language requirements

necessary to obtain the visa vary from course to course, and are liable to change periodically. The university and college websites will give details of what they ask for in terms of English, and will also give guidance about visa issues.

Students from non-EU countries, studying on courses of a duration of six months or over, will normally need a Tier 4 study visa. The timescale between being offered a place, getting the visa and then starting the course will depend on a number of factors, including where you live, where you intend to study and the start date of the course. The application steps are:

1 Obtain an offer of a place from an FE (Further Education) institution for A level courses, Foundation or equivalent; or from an HE (Higher Education) provider for degree and postgraduate courses. This may be based on an interview, your portfolio or other assessment criteria. The school, college or university must have a UKVI (the UK's visa-issuing authority) sponsor licence.
2 Accept the offer and, if required, pay the deposit or fees.
3 The institution will then issue you with a CAS (Confirmation of Acceptance for Studies) number, which you then use in your visa application. The institution applies online for your CAS number and the UKVI will match your details (name, nationality, passport number, evidence used to make the offer, course details, etc.) with the CAS number on your application.
4 If the visa office is satisfied with the documentation and also, if required, the evidence that you have the funds to pay for the course and to fund accommodation and other living expenses, it will then issue you with your visa.

For the most up-to-date information on visas, you should go to the UK Visas and Immigration website (www.gov.uk/browse/visas-immigration/student-visas).

Plate 1 Workshop for A-level students organised by the University of the Arts London

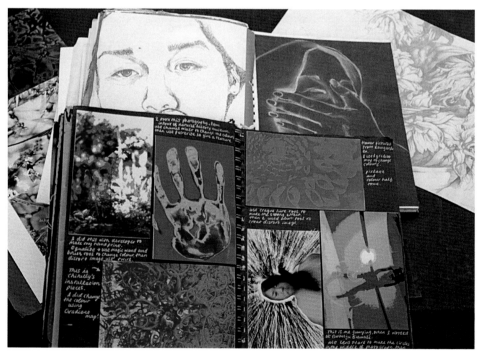

Plate 2 A level sketchbooks

Plate 3 A level sketchbooks

Plate 4 Falmouth University Graphic Design students

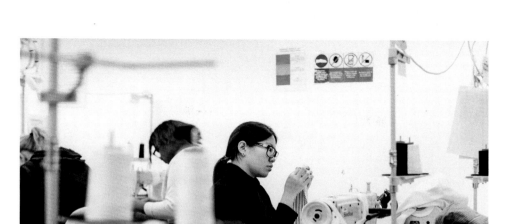

Plate 5 Falmouth University Fashion student

Plate 6 Falmouth University Art Foundation beach project

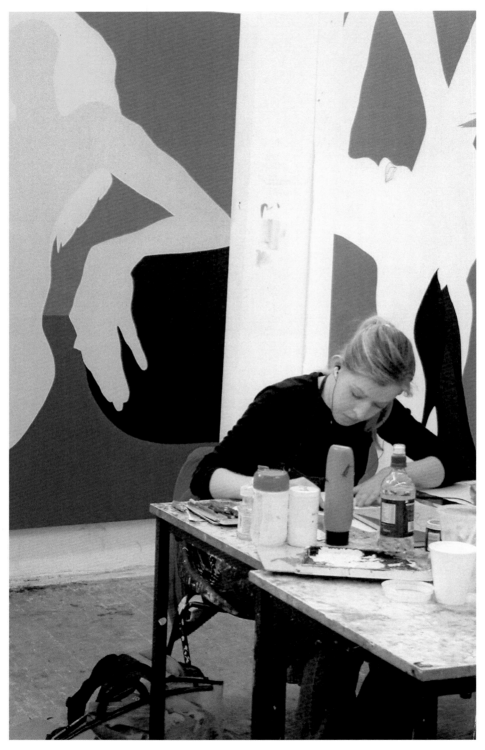

Plate 7 Fine Art studio

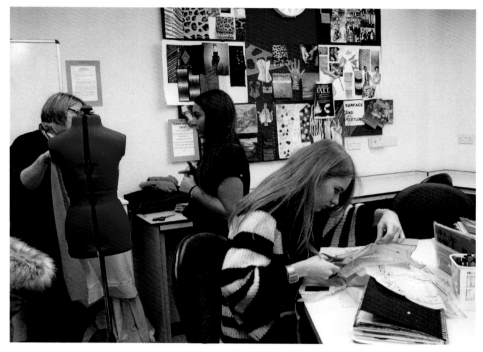

Plate 8 A level Textiles students preparing examination pieces

Plate 9 A level students setting up their end-of-year exhibition

Plate 10 A level student hanging her work for the final exhibition

Plate 11 A level student displaying her work for her final exhibition

Plate 12 Part of the final Fashion BA collection, Annabel Knowles, Bristol UWE

7 | Putting together a portfolio

For most students making the move into further or higher education, the offer of a place is normally made on the basis of past academic performance, personal statements and references, predicted grades for forthcoming examinations and, increasingly, an interview. With art school applicants, all of the above applies but with one very important addition: you will need to show the college your work in a portfolio. Whatever the particular format your interview may take (discussed in Chapter 8), you will turn up with your work, the college will look at it and you will get the chance to talk about it and yourself, as well as to ask and answer questions.

For some this may seem a daunting prospect. Most artists worry about showing their work to others. It is not surprising when you think about it. Having put our heart and soul into what we do, naturally we worry about negative judgements. Do not panic! Attending an interview with a portfolio of your work gives you a big advantage. Unlike your contemporaries who rarely get the chance to show what they can do except in exams, not only do you get to show what you are best at – being creative – but you also have plenty of time to prepare in advance, a good idea of what to expect, and all the people interviewing you will be artists themselves so they will understand what you are doing.

What is a portfolio for?

All of the colleges that you apply to will be interested in your qualifications, references and experience, but above all they will be concerned with who you are, what you have done and what your potential is. Demonstrating these things is the function of the portfolio.

What is a portfolio?

A portfolio is a folder containing examples of art and design work. Professional artists and designers need to take their portfolios to job interviews. You will show your portfolio to the admissions tutors of the courses to which you apply. Portfolios come in all shapes and sizes and in many cases you will be able to use the same one (normally A1 size)

in which to display your work for both Foundation and degree applications (though obviously the contents will be different!).

There are some exceptions. For example, a student applying for a specialist degree course in photography might choose to use a portfolio specifically designed for that purpose. They are often smaller and are sometimes referred to as 'books'. In fact, the term 'portfolio' can be used to describe any collection of works for presentation even if they are not actually displayed exclusively in a folder.

Which portfolio should you buy?

At this stage, do not buy one at all. Wait until you have read the whole of this book, have had a chance to think things over and, most importantly, have some idea of what you are going to put in it. As a guide, buy the best one that you can afford, as it will protect your work better and be a saving in the long term. Look at the quality of the zip if it has one and check that the ring binder works well. Is the handle strong and comfortable? When thinking about sizes, consider how big your work is. On the other hand, do not bite off more than you can chew. If you cannot carry it, it is too big! Above all, though, remember that it is the quality of your work that counts and not the quality of the thing that you carry it in.

Getting your work together

The following guidelines apply to portfolios for both Foundation and degree course applications. Read them carefully: they describe the qualities that you should look for in your work and will help you make decisions about which pieces to select. Later in this chapter there are also sections giving guidance on the requirements for each type of portfolio. Make sure you read the contributions made by course tutors.

The first step in putting together your portfolio is to gather together all of your work. When you do this it might be tempting to say 'I won't need that' or 'That's no good', but at this stage just concentrate on getting all of your work in one place so you can see what you have got: finished pieces, unfinished pieces, sketchbooks, models, notebooks, written work, old work, new work – get everything! This is important because not only will you find things that have been tucked away that are actually very good, but also, as you look through your work, you will begin to see relationships emerging between new and old pieces. A small sketch that at first may seem rather unimpressive might have inspired a later,

much more accomplished piece. The ability to make judgements and to evaluate what you have done, to recognise a good idea and to develop it further, is an important part of the creative process. Admissions tutors will be assessing to what extent you are able to do these things.

It may help you to organise your work into categories. The following list will provide you with a starting point:

- contextual studies/written work
- drawings from observation
- drawings of invention
- finished pieces
- life drawings
- models and maquettes
- sketchbooks/journals
- sketches and studies
- works in progress.

The importance of drawing

Albert Einstein used the formula $E = mc^2$ to express his famous theory of relativity. Scientists use mathematics to express and explore their understanding of the world and how it works. Artists and designers do this with drawing.

Drawing could usefully be described as the act of making marks to convey meaning. Artists and designers use drawing to record observations, work out ideas, pass on information, express feelings and emotions and resolve practical problems. Drawings are often used to help us visualise how things fit together. For example, scale drawing can be used to work out whether all the units of a kitchen will fit into the space available. Diagrams and flowcharts can be used to demonstrate how ideas and principles relate to each other. Drawings come in all shapes and sizes and are made with a variety of different purposes in mind. Examples of types of drawing include:

- life drawings
- observational drawings, such as those done from a still life or made in the field (e.g. architectural details)
- plans and designs
- sketches and drafts.

Whichever course you apply to, the admissions tutors will want to see your drawings in one form or another because they are evidence of your visual intelligence. Your drawings demonstrate that you can perceive, understand, invent and communicate visually. These abilities are at the core of successful art making.

Sketchbooks

Sketchbooks fulfil many purposes. They are a place in which artists and designers begin the creative process. They are also a place in which to store cuttings, postcards and virtually any other articles that will fit. They are the place in which you can put your ideas, thoughts and feelings down on paper. Typically, interesting sketchbooks contain visualisations of many types, made by you for a variety of reasons.

These images might take the form of carefully studied observational drawings or quick sketches or doodles. In a sketchbook you will refer back to previous ideas and make relationships between the images on one page and those on another. Perhaps you have spent some time experimenting with different ways of making marks. You will be familiar with many of the effects that you can get with a pencil, but what kind of drawings could you make with a nail? A sketchbook or journal is the place where you might try something like this. Maybe you have been using your sketchbook to work out the volume of a space so you can calculate how much concrete you would need to fill it? Why would you want to know? At this stage you are probably not completely sure and you do not need to be.

The sketchbook is a place where you can try things out even if they seem crazy; it will reveal the extent of your curiosity. In this sense, sketchbooks can be highly personal and frequently become much cherished. They also provide evidence of your creative development because they are time-based.

With very few exceptions, course admissions tutors will want to see your sketchbook work.

Project work

Project pieces might be two- or three-dimensional or time-based (such as video) and may use a variety of media. Normally they will have been completed on your current course of study and will show to what extent you have taken advantage of the training and support you have been given.

The ability to undertake and complete a project, whether it is self-determined or in response to a set brief, is one of the qualities that prospective art schools and colleges look for. Work developed over an extended period – formed by experimentation, contemplation, reflection and risk taking – says a great deal about its creator.

- Are you willing to stick with something to the end?
- Will you test a theory to the point of destruction?
- Can you keep an open mind?

A project piece will demonstrate your imagination, invention and skill and give evidence of your willingness to condense your theories and commit to a final outcome. If it has been made as part of a group project it will also show your ability to work with others. It can also be very helpful to include some work in progress in your portfolio. Unfinished pieces can have a freshness and ambiguity that often stimulates conversation.

Overly prepared portfolios in which everything is polished to perfection may come across as stifled and dishonest. Including an unfinished piece or two will help to avoid this problem.

Personal work

Most artists and designers have a strong desire to be creative. Whether they are extrovert or introvert by nature, creative people have a need to express themselves. Inevitably, this does not stop when you leave the classroom or studio. Personal work may take a variety of forms, but its essential qualities are that you did it because you wanted to, it contains your own opinions, thoughts and feelings, and it was made to fulfil your needs. Maybe you feel strongly about something and want to make a point or perhaps you are in a band, have recorded a demo and need a CD cover. In both cases, you would naturally have a need to create. Personal work says a lot about who you are and demonstrates your passion and commitment.

Contextual studies/written work

Written work is often overlooked at interview but should be included if possible. At degree level it will be a requirement to complete some form of contextual study, and on a Foundation course you can expect to be fully engaged in critical thinking (although you probably will not be required to produce an extended written piece). Reflecting on the work of others and responding to its qualities are fundamental parts of the creative process. This work will give you the chance to demonstrate your ability to explore ideas and concepts and learn from the work of others and, in many cases, will show how you are able to make choices about typefaces, justifying text and formatting illustrations.

Matching your portfolio to the course specification

Make sure that you read the course's portfolio specification thoroughly. Talk things through to make sure that you are clear about what is required. Each course will have its own requirements. For example,

many courses ask you to limit your portfolio to a particular number of pieces. Whatever the requirements are, respect them; they will be there for a reason and are your best guide to what to include. In many cases it will be necessary for you to adapt your portfolio for each course to which you apply. Make sure that you give yourself time to do this.

Special considerations

It may not be possible to take all of your work to the interview; perhaps it is too big or too fragile. For practical reasons, art schools and colleges inevitably have to put some restrictions on what can be accepted. If this is the case, in most instances it is perfectly acceptable to take slides or photographs, but do check with the admissions tutors first. Original work is preferable if possible, and if you do take photographs make sure that they are good ones.

> **TIP!**
>
> Label your portfolio – make sure that you clearly identify your work. You do not want there to be any confusion about who did it and you want to make sure that you will get it back. This is particularly important if you have to submit your portfolio in advance of the interview – do put your name and address in an obvious place.

Digital portfolios

Many institutions accept or even encourage you to submit your portfolio digitally. This could be in one of a number of formats:

- uploading images of your work to a web-based site such as Instagram, Flickr or YouTube
- submitting your work on a USB stick
- burning a DVD or CD
- creating your own website or blog in which to showcase your work.

Your chosen institution will give you advice on the number of pieces, the type of work it wants to see, and technical information on the format it wants the work in, and how to upload it or send it.

> **TIP!**
>
> - Ensure that you use digital file sizes that are neither too large (in case they cannot be attached to an email or downloaded easily), nor too small so that the quality of the image is not sufficiently good for a selector to assess your work.

- If you are photographing your paintings, drawings or 3D pieces, use a good-quality camera and ensure the lighting is good. Avoid shadows, reflections, camera glare or distracting backgrounds.
- Make sure that everything is labelled clearly: your name, any titles of the works, when they were made and any other information you feel is important. This might include materials you used, techniques or influences.

Enrolling on evening courses

Evening courses can be a valuable source of extra tuition. They give you a taster of what being at art school is like and can be a lot of fun. For mature applicants, they provide the opportunity to work with teachers and become reacquainted with a teaching environment. If you do not have access to a life model, for example, consider taking life-drawing classes. Courses could be theoretical in nature and could cross over into other disciplines that are new to you, for example animation. Not only will this help to build up your portfolio, but it will also be an excellent demonstration of your commitment.

Portfolio reviews

Many schools and colleges offer portfolio review sessions, sometimes leading up to mock interviews. Certainly your teacher or tutor will offer you advice and support. Remember, you are not always the best judge of what to put in and what to leave out of your portfolio. You are going to need a second opinion, and taking the advice of an experienced teacher will help enormously.

Freak-outs

Most artists feel overwhelmed from time to time – it often goes with the territory for those of us who are willing to test things to the limit. The process of putting together a portfolio can feel stressful at the best of times, and if you leave everything to the last minute it will be even worse. You also need to make sure you leave time to think about what you are going to say at interview.

When a group of A level students applying to art school were asked 'If you could give a fellow art school applicant one piece of advice on

how to put together a portfolio, what would it be?', their unanimous response – which they all shouted out – was 'Start early!' Setting manageable weekly deadlines and keeping an honest record of what you have and have not done will help enormously. Set specific goals such as 'I need more life drawing'. Not convinced? Read on.

'The other students seemed so confident, so cool, and were carrying so much work. I felt very intimidated. But the interview itself was much less stressful than I had thought. The interviewer asked me to choose one piece from my portfolio and explain its story – where I got the idea (from an exhibition I had been to), what preliminary work I did (I showed him some sketches and colour swatches in my notebook) and how I would develop the idea (I hadn't thought about this but talked a bit about incorporating some collage into it next time). He smiled and encouraged me all the time. And I was offered a place!'

Pat

'I had two interviews for Foundation courses, at UAL and Kingston. The thing that they had in common was that the atmosphere was very relaxed in both interviews, more like a chat about my likes and future plans. The interviewers seemed interested in my portfolio work and allowed me to talk about the pieces I liked best, prompting me with questions about ideas for future development of the pieces, or where I got the ideas from. The difference was that for one of the interviews, the university had run a workshop at my college a month before, on how to prepare for their interviews, so I not only knew what to expect but I had also met my interviewer before. So I went in feeling confident. At the other interview, I had three people in the room asking me questions so I was much more nervous. My advice for students applying is to find out as much as you can about the interview process in advance by talking to current students – ask your school for the names of previous students who have gone to the university.'

Charlotte

'The most difficult part about my Foundation interview was the waiting. There were 20 students being interviewed that day and we all sat in a student common room at the college and were called in one by one. We didn't know who would be called next. Some of the students talked to each other but everyone was very nervous, and we all kept checking our portfolios to make sure everything was there. The actual interview was fun! I was asked to choose one piece from my portfolio and to talk about why I had created it, why I chose it for the portfolio, and what I wanted to do after the Foundation. At school we had done some practice interviews with a visiting local artist and so we were used to talking about our work. I got the offer so it must have been fine. My advice

for prospective applicants is to become confident about talking about your work by practising as much as possible – preferably in front of strangers!'

<div align="right">*Chris*</div>

'I hadn't been given much advice from my previous school about applying for art courses, and didn't realise that I needed to do Foundation. I just assumed that I would apply for the fashion degree I wanted to follow. My portfolio was full of fashion sketches but not much else. My UCAS applications were rejected without interview but one college did contact me and asked me to come to a Foundation interview. They were very nice but didn't offer me a place because my portfolio "showed no real variety or evidence of research". They advised me to take another year of A level and to do textiles and photography in a year and also get help on my portfolio. I was annoyed at first, but in fact the extra year taught me so much about finding sources of ideas and developing them into something personal. I got offers from all of my chosen Foundation courses, and ended up here at UAL. My advice – research courses and their requirements.'

<div align="right">*Billy*</div>

'Make sure you get someone to help you to practise before the real interview. Not to rehearse as if you were in a play, but by asking you questions about your work; ideas; future plans. I was lucky because my school organised practice interviews and portfolio crit sessions but I met some people at the interview who were very, very nervous because they had no idea what to expect.'

<div align="right">*Libby*</div>

Foundation course portfolios

Your Foundation course portfolio should contain as wide a variety of work as possible. You may think that you are heading for a career in fashion design, but you are applying for a diagnostic course that aims to confirm that choice for you or point you in another direction. Tutors want to see potential in all sorts of areas, so include:

- colour work made in a variety of media
- contextual studies or written work
- drawings and paintings made from observation and imagination, using a variety of media
- examples of design work and model-making
- life drawings
- multimedia work such as video
- photography

- photographs of three-dimensional work if it is not possible to transport it
- printmaking
- project work made on your current course and for yourself
- sketchbooks.

Don't worry if you cannot include all of these; very few students are able to. Remember that admissions tutors will primarily be looking for potential and motivation.

What ECA admissions tutors look for in a portfolio

Birgitta MacDonald, Director of First Year Studies (Art and Design General Course) at Edinburgh College of Art (ECA), has the following advice about your portfolio.

The portfolio tells us about you. It tells us what art and design experience you have had and what kind of course you have followed. It tells us about your imaginative and creative responses to ideas, to observations, to process and to concepts. The portfolio will be looked at to assess the individual candidate's enthusiasm, creativity, intellectual and practical skills in the practice of art and design.

Consideration will be given to the candidate's potential for further development and progress in any of the fields of art and design the college has to offer. The admissions panels will also be looking for signs of the following student attributes:

- *strong portfolio displaying research, visual and manipulative skills based on the portfolio grading system used in First Year Studies at ECA*
- *a willingness to broaden the existing skill base and to be fully committed to a broad, general, diagnostic first-year course, leading to specialist study in the second year*
- *good communication skills – visual, verbal and written*
- *an inquisitive nature and an ability to demonstrate intellectual curiosity*
- *self-motivation and drive*
- *organisational skills (timekeeping, presentation of folio, etc.).*

The portfolio should include representative examples of work undertaken as part of a programme of study and/or personal research. The compilation of a portfolio should not be regarded as an end in itself, but rather as one of the results of that study.

The portfolio is the primary means by which a candidate presents herself/himself to the admissions panels and it should be prepared

accordingly. Logical presentation assists in this and there is much to be gained by grouping work in categories such as drawing, painting, two-dimensional design and so on, in chronological order. It is also valuable to be able to trace the development of a work and preliminary studies are best presented with the final work.

There should be evidence of study and investigation, the exploration in depth or in breadth of a subject/interest in a sustained way. Portfolios should display, in some form, evidence of developing skills relevant to artistic practice – for example drawing skills, colour investigation, making skills, photographic skills. Alongside these there should be evidence of a lively interest in the collection of relevant research materials such as photographs, magazine articles, historical data, collected objects and personal notes. The admissions panels will pay particular attention to candidates' note-books/sketchbooks, especially with regard to the extent to which they reflect the range of a candidate's interests and experience.

Specialist course portfolios

While this portfolio should contain a range of work demonstrating your all-round ability, you will obviously need to demonstrate a commitment to a particular area of study and show a level of skill and ability in that field. However, admissions tutors will be realistic about the extent to which you will have been able to develop your skills and will very much be looking for potential and motivation. Items to include are:

- colour work made in a variety of media
- contextual studies or written work
- drawings made from observation and imagination, using a variety of media
- life drawings
- personal work in your specialisation made for yourself
- photography
- photographs of three-dimensional work as required, if it is not possible to transport it
- project work in your specialised area of study made on your current course
- sketchbooks.

With respect to your specialist project work, use the following examples as a starting point for ideas on what to include. As a rule, your portfolio should contain a sustained project made within your proposed area of study. Contact the course admissions tutors if you are unsure about what to put in.

Fashion

Drawings; sketches; fashion designs; photographs or actual examples of garments you have made; a collection of information on particular designers, fashion manufacturers or shops; a design project worked on to a brief; evidence that you read fashion magazines and follow developments on the catwalk.

Film, TV and animation

A short film that you may have made as part of a course project; scripts; storyboards; a subject-dedicated sketchbook; evidence that you regularly watch films and read reviews.

Fine art

Paintings and/or sculptures, photographs, textiles and pieces of work produced to a negotiated brief; original pieces, produced entirely from your own ideas; evidence that you read art magazines and visit exhibitions.

Graphic design

Lettering; samples of freehand drawing; examples of work showing page layout; projects relating to advertising, publicity or packaging; typography; work completed to a brief, such as a complete publicity campaign for a product; digitally manipulated images; evidence that you read design magazines and visit exhibitions.

Illustration

Work done from direct observation; work related to a design and technology project (if applying for technical or scientific illustration courses); work done to a brief – for example, a piece done to illustrate pages of a particular book, with sample text and notes explaining how you set out to emphasise particular aspects; evidence that you read appropriate literature and visit exhibitions.

Product design

Drawings, diagrams, computer-aided designs; working notes showing that you understand the workshop processes necessary to manufacture the product; preliminary sketches; photographs of the finished article; evidence that you read design magazines and visit exhibitions.

Guidance on portfolio preparation for specialist courses

'Interviews are an opportunity for you to demonstrate your commitment and self-motivation to a chosen area of study, and to discuss aspects of your chosen course and ask any questions that you may have. You will be expected to display and discuss your portfolio. Portfolios should contain examples of work (both finished and in progress) that showcase your particular interests – not only course or school work, but also any independent work, including, for example, sketchbooks and any other evidence of your ideas, your interests and passion for your chosen area of study.

'The form of portfolio work desired would vary according to the area of study. For example, the BA (Hons) in Costume course would require extensive evidence of figurative drawing whereas the BA (Hons) in Model-making would require that you show items that you have made, whether in pottery, wood or fabric. The common requirement across the board of courses is that you show evidence of your commitment to your area of study and an ability to visually express your ideas and concepts and show the creative development of your artwork from start to finish. The creative process is an important feature rather than the outcome. Passion for your chosen area of study is also essential as well as the ability to demonstrate and show your potential within a variety of artwork pieces.'

Astrid MacKellar, Arts University Bournemouth

The skills your portfolio should demonstrate

Sarah Horton, BA (Hons) Course Leader at Norwich University College of Art, has further advice.

- **Drawing:** *evidence of life drawing can be useful because it demonstrates such a particular discipline, but any drawing that shows you can observe and interpret the world around you is important. Drawings can be any scale and in any medium, but a diversity of approaches shows exploration and a keenness to experiment.*
- **Problem-solving:** *your ability to solve visual problems can be demonstrated through design sheets or sketchbooks, but should show in detail how you would deal with design briefs or your own (if more fine art-based) issues or ideas. If anything, these are the most revealing parts of the interview, and for many staff it is more important than seeing finished pieces.*
- **Diversity:** *a diversity of work and a willingness to experiment are crucial. A good problem-solver needs to*

use any number of techniques and approaches, so you must show flexibility and adaptability. If you come with only one method of working, your methods will look narrow and limited.

- **Consistency:** *as well as diversity, you need to show that you can also take an idea and 'run with it'; that you have developed, in some depth, one or more particular projects or themes.*
- **Independence:** *at degree level you will need to be able to generate work that is self-directed and independent. Your portfolio, therefore, needs to show that you have developed your own ways of working that haven't been directed solely by your tutors.*
- **Critical/contextual studies:** *most degree courses have a theoretical element, usually involving written work, so something that shows your ability to write is also important. Interviewers will also need to know that you are interested in the broader context of art and design. You will be asked about practitioners who have influenced or impressed you and exhibitions you've recently visited.*

Finally, it is impossible to quantify the amount and type of work to take to an interview. While you should include a full range of work that isn't over-edited, you should select carefully rather than include absolutely everything you've ever made! Emphasise your most recent work as this is the work that best represents your current concerns. Because it is fresh in your mind this is also the work you'll be able to talk about with the most enthusiasm.

The key to your portfolio is its organisation. Have a strong beginning and end, and order your work coherently in projects or subjects, giving most emphasis to recent work. Listen to advice from tutors: they have great expertise in helping students gain university places. For three-dimensional or large-scale work, bring good-quality photographs or slides. Better still, bring originals, but good reproductions will often suffice.

'Ideally, we would like to see a portfolio that demonstrates a high level of visual skill, creativity, commitment and self-motivation. We would be looking for evidence of intellectual enquiry and cultural awareness. We would expect you to have completed a Foundation course and the resulting portfolio may include sketchbooks, ideas books, set projects, self-initiated work, finished pieces, work in progress, photographs or three-dimensional work.

'We value a portfolio of work that includes continuity of ideas, and a series of related images that relate to each other in some way. We are interested in your research, thinking and projects that show the development and progression of an idea. We particularly value self-initiated work because it tells us so much about you! Your portfolio should be self-explanatory – it may be viewed initially in your absence. Edit your work and play with the sequencing of images and projects until they unfold in such a way that they tell us who you are and what you think. And, above all, we are looking for potential.'

Debbie Cook, Tutor at the Royal College of Art and International Postgraduate Coordinator at Central St Martins

'A portfolio should speak for itself and tell us about your ideas, your passions and your personal approach to working. A commitment to the subject and an engagement with projects should be evident. You need to be self-motivated and have the capacity to work independently and this should be reflected in your portfolio. We are interested in the journey your work takes, your ability to recognise and generate ideas, explore their possibilities and develop them. This process of thinking and working, within a broad cultural context, is crucial. Finally, present your work in a clear and organised way to ensure that it communicates all that you want it to.'

Annette Bellwood, International Academic Coordinator, London College of Communication

As soon as your portfolio is opened it must capture attention. To help you achieve this, here are some general guidelines from Hereford College of Arts' website (www.hca.ac.uk/How-to-Apply/Your-Portfolio).

- **Preparation:** be prepared to adapt the portfolio according to the course you are applying to.
- **Sequence:** the portfolio should be well organised – so that whoever looks through it understands how you develop your ideas and how you move from one idea to the next. Also include notebooks and sketchbooks.
- **Scope:** show the range of what you can do, concentrating on recent work. Include visual and other background research, sketches, models and prototypes – not just the finished work.
- **Context:** it should show whatever interests you, and how your interests influence the work you are passionate about – fashion, music, sport, environment, etc.
- **Selection:** pick work that shows ideas, skills and media that you want to explore further in the course that you would like to do. Don't include too much and avoid repetition of one kind of work. Generally, 15 to 25 items for a portfolio should be enough.

- **An objective eye:** you may find it helps to ask a friend or a tutor to look at your portfolio to see if it shows you to your best advantage.
- **Labelling:** make sure your portfolio is clearly labelled with your name and contact details!

WARNING!

On no account even consider 'borrowing' someone else's work for your portfolio. As well as being unethical, you are almost certain to be found out, as the differences of style will be quite obvious to the trained eyes of the interviewers.

Checklist

- Round up your work.
- Check out courses' portfolio specifications.
- Purchase a portfolio.
- Attend evening classes.
- Review your portfolio.
- Set targets and deadlines.
- Photograph three-dimensional work.
- Label your portfolio.
- Adapt your portfolio to a particular specification.

8 | The interview

This chapter is about how to make the most of your interview. Although the format of the interview will vary from college to college and there are differences between interviewing for a Foundation course and a specialist degree course, the following guidelines will be of help to you. Make sure that you read this chapter in conjunction with Chapter 7.

What is the purpose of the interview?

Interviews are there to help art schools find the most appropriate students and to help students find the most appropriate art schools. Most people who fear interviews do so either because they misunderstand their purpose or because they do not know what to expect and imagine the worst. We worry that we will be asked impossible questions, that the interviewers will not like us or that they will try to catch us out; we worry that we will not be good enough.

Consider this: art schools exist because students want to study art and design. Without the students there would be no colleges, no lecturers, no admissions tutors and no courses. In other words, where would art schools be without you? You are the single most important element in the educational process and, as such, it is not in any college's interest to make life difficult for you. Yes, interviewers will be trying to find out whether you are suited to the course for which you are applying and, yes, they will be carefully considering both you and your work and, yes, you can expect to be asked some challenging questions – but try to take a positive attitude. Most people are nervous at interview; admissions tutors understand this and will make allowances. They are there to get the best from you.

Also, remember that the interview provides you with an opportunity to assess a prospective college. Hopefully, you will have visited the college before your interview and checked things out, but a second look around will not do you any harm. Since you will probably be studying under some of the people who will be interviewing you, check them out too.

What to expect

In some colleges you deliver your portfolio for consideration prior to being offered an interview. At others, you leave it with the admissions

tutors on the day of your interview, they initially look at it without you and then ask you in to discuss it with them. This can happen 10 minutes after they take it or sometimes later that day. In many instances, especially at interviews for degree courses, you begin your interview by being asked to present your work briefly to an interviewer or a panel of interviewers who are seeing it for the first time. In many cases, a conversation begins as you show your work, developing into a more formal question-and-answer session towards the end of the interview. However, interviews vary from college to college, so before attending read through the college's literature to find out what the format will be.

Interviews vary in length from as little as five or 10 minutes to up to 30 or 40 minutes for specialist degree courses. Do not be surprised or worried if the interview feels as if it was very short. Time seems to pass much more rapidly in this kind of situation. Also remember that the interviewers are experts, know what they are looking for and often will be able to come to a decision quickly. This is particularly the case for Foundation courses, where admissions tutors will frequently have to see literally hundreds of students in a matter of weeks.

In some cases you will find out if you have been successful on the day, but in most cases you will be notified by letter in due course.

Preparing

It is impossible to know exactly what you will be asked at interview, and in some ways it is not helpful to be overly prepared since it is much better to allow a discussion to develop naturally, answering the questions that you have been asked rather than insisting that you talk about what you have been reading up on. However, while being over-prepared is one thing, being under-prepared is quite another and should be avoided at all costs – it will suggest to the interviewers that you are not really interested in the course. The best way to prepare is to think in general about how you might respond to the specific questions you know that you are likely to be asked. As a guide, consider the following.

- Why have you applied for this particular course?
- Why have you applied to study it here?
- Which artists have influenced you?
- What are you hoping to do in the future?

If you have been conscientious about choosing a course, you will be able to make a positive response to the first two questions. (Make sure that you have read Chapters 2 and 3.) Rereading your notes and personal statement, looking through the course prospectus and talking things through with others will all help. Rather than trying to 'revise' for

the answers that you think the interviewers will want, simply remind yourself of what you have done, so that you can respond honestly.

With respect to the question 'Which artists have influenced you?', before going to the interview look through your work and consider how it relates to that of others. If you have worked on a written project, reread it. Looking through your sketchbooks can also help, since they are, in part, a record of your creative process. You will probably have collected cuttings and postcards. These visual prompts will help to remind you of your influences.

During the period leading up to your interview, make a point of getting out and about. Make sure that you visit some exhibitions. In addition to looking at well-known exhibits in museums, go and see a show of new work. Also, keep up to date by reading the arts pages of national newspapers and periodicals – see the reading list in Chapter 12.

If you are applying for a place on a Foundation course it is likely that your future plans will include taking a degree. You can say this. If you are applying for a place on a specialist degree course, jotting down a few notes to help you think things through may be helpful in preparing for the fourth question, the one about your future plans. Whatever your thoughts might be, do not worry if you cannot come up with a complete answer. That is perfectly normal. It would be a pretty boring world to live in if we all knew exactly what we were going to do in the future! You just need to be able to show the interviewer that you are reflecting on your options and have some possible ideas in mind.

Assuming that you have done your homework and know as much as possible about the course, you will not need to use up valuable time asking questions about course structure or discussing specific issues such as funding. If you are given the chance to ask questions or make comments, it is usually much better to respond to something you have just been discussing with the interviewer than to set your own agenda.

Perhaps the best way to prepare for this is by taking a mock interview, which will give you a feel for how an interview develops. Many schools and colleges offer mock interviews to their own students and in some cases to external candidates. If you have the chance to do one, make sure you do not miss out. Mock interviews provide excellent preparation and an excellent way to identify and resolve potential problems.

Discussing your work with art college or university teachers can be a daunting prospect and you will need to practise before your interview. As a general rule of thumb, try to structure any discussion of your work as follows.

1 Where the idea for the piece came from. This is an opportunity to talk about artists whose work you like, exhibitions you have visited or previous work that you have produced.

2 How your ideas were realised in the piece. You could talk about the composition, the materials and the techniques you used as well as what the work represents.

3 Where the work will lead you. You could talk about what you will work on next, what you might have done differently or how the piece has led you to investigate other artists or techniques.

The interviewer will help you by asking questions and possibly suggesting other areas of research.

Practicalities

As well as thinking about the kind of questions that you might be asked, it is also important to consider a few practicalities. For example, how will you be travelling to the interview? If you are applying to a local art school you may only have to make a short journey. On the other hand, you may be applying to a course a long way from home, so consider the logistics. In some cases an overnight stay may be necessary.

Also think about how you intend to transport your work. In many instances you will be able to carry everything in a portfolio. As has been mentioned, most colleges are happy to look at photographs of three-dimensional or larger pieces. However, in some situations (e.g. with pieces under a certain size) it will be necessary to take this work with you. You may need to ask a friend for help or to ask the college for advice.

Practise your presentation technique. Can you comfortably manage your portfolio or is it too heavy?

Some international students are interviewed using Skype and a web-cam. If your interview is going to be done remotely, do you have a good internet connection? Is your webcam of good enough resolution to show your work properly?

The night before

Assuming that you are well organised, there should be nothing left to do except relax and get a good night's sleep, so make sure that you do! Easy to say, difficult to do. We all get nervous before a big day and you might find it difficult to switch off. Don't worry if this happens – it just means that you're normal. Try doing something to take your mind off things, like watching a film, chatting with friends or maybe taking a little gentle exercise, and try not to worry. Be positive. Remember, art schools cannot exist without students!

The interview itself: some tips

- Make sure you arrive early. You do not want to be rushing around at the last minute.
- Dress comfortably. Your interviewers will be far more interested in who you are and what you do than what you wear. If your hair is bright blue and shaved on one side, fine. If it is not, well that's fine too. You will need much more than a good hairstyle to get into art school!
- Make eye contact. If you are asked to show your work, make sure that you do not turn your back on the interviewers. Try to position your portfolio between yourself and the people you are speaking to, or, if you are standing side by side, turn towards them from time to time.
- Be willing to listen as well as talk. Sometimes when we are nervous we talk too much. Try to listen carefully to the questions that you are being asked. You will respond far more intelligently if you understand what has been said. If you do not understand, do not be afraid to ask for further explanation. Sometimes there will be pauses in the conversation. Do not let this unnerve you: the tutors are just concentrating while they look at your work.
- Understand *why* you have been asked to attend an interview. It is because what the university knows about you so far (what you have written in your Personal Statement, your work that they have seen on Instagram, your academic history or what your teachers have written about you) leads them to believe that you would be a valuable presence at the university or art school, and that you have the potential to become a successful artist, designer or architect. So be confident!
- Be willing to consider new ideas. You will be very difficult to teach if you find it hard to keep an open mind. Try not to become defensive if some of your responses to questions are challenged.
- Be yourself. You do not need to put on an act. Never try to bluff or lie. You will always be found out, so only show your own work and if you do not know something then say so.
- Above all, be enthusiastic. Do not be afraid to express your commitment and passion for your subject. You will have worked very hard up to this point. Let your interviewers know that this matters to you. Try not to be cool. Art schools are looking for motivated students.

HOPE

Use the acronym HOPE as a reminder of the personal qualities that you will try to display at interview:

- honesty
- open-mindedness
- preparedness
- enthusiasm.

Meet up with a friend and talk things through; this will help you to put things into perspective. Also it will greatly help your fellow students if you give them some feedback. They may not have had an interview yet and your experience will be beneficial. A day or two later, when you have had the chance to reflect a little, make a note of anything that sticks in your mind that might be helpful for next time.

'The application and interview process for an art and design Foundation course consumes a lot of time, so I would recommend starting it as soon as possible as you will still have your studies to keep up with. Requirements include written applications and a strong portfolio that reflects a variety of skills.

'Loughborough University's application process was different to others that I applied to as I had to complete a bespoke drawing project: a linear and mark-making pencil study of the bath, bath taps and other bath objects. To achieve a piece that I was happy with, from a composition and quality perspective, took many attempts. I also had to provide a personal statement in the form of a handwritten essay, of a maximum 300 words, specifically outlining my reasons for applying to the Foundation programme at Loughborough.'

Kieran Wye
Loughborough Art & Design Foundation

'My interview was very informal, and although we looked at my portfolio for around 15 minutes, a lot of the questions were much more general, about my interest in art, my career plans, which exhibitions I had been to. He also asked me about the university's website – did I like the design, was it helpful, was it inspiring? I think that he wanted to be sure that I was serious about applying there, and whether I had done my research.'

Lily Wong, University of the Arts London
Foundation course student

'My preparation for my fashion degree course interview at Bristol UWE included designing a little booklet about the university, to show that I was interested in the university as well as the art campus and course. I knew they would ask me about a designer I liked, so I chose someone not so well known, as I though everyone else would go mainstream. I made sure that my portfolio included things other than fashion as well. I was asked why I chose Bristol, and lots of questions about my portfolio such as "why did you do the stitching like that?". I was very relaxed at the interview because I made a point of being sociable with the other students who were also waiting to be interviewed.

'Even though the degree was a fashion course, I still had to do other things in years 1 and 2, such as textiles. It was only in the third year that I could steer the degree more to my own interests.

Preparing my final collection was exhausting and I would fall asleep within seconds of lying down. We were given two hours a week with teachers and pattern cutters but the rest was all down to me. Money was also an issue as we had to buy all of our own materials. The department chose who would show their work, so although the atmosphere was competitive, we still had to cooperate and get on with each other.'

Annabel Knowles, BA Fashion

Admissions tutors' advice for interviews

- *'In interviews, the reviewers are looking for students who demonstrate curiosity about why the world looks like it does.'*
- *'I will expect them to talk about books, journals and shows, and to be able to get under the skin of a subject.'*
- *'Make sure you convince your interviewers that you are passionate about the subject and the particular course you are being interviewed for.'*
- *'When I meet prospective students, I am looking for potential.'*
- *'If you are closed to new ideas it will be impossible to teach you and your place will be offered to someone else.'*
- *'Interview questions focus on both how and why the work [in the portfolio] was produced and how it might develop.'*
- *'I am not interested in technique – technique can be learned – I am interested in ideas and an open mind.'*
- *'If the student I am interviewing hasn't been to see any exhibitions or shows recently, I tend to doubt their real interest in studying art.'*
- *'Your interviewers are looking for creativity and a willingness to experiment.'*
- *'The internet means that no one, however far from a city, has any excuse not to explore new ideas and get inspiration from practising artists.'*
- *'Be as chatty as you can in your interview. We are looking for good communicators who will share their ideas and not be afraid to discuss their own work.'*
- *'We want to make sure that you are energetic, excited about your future studies and, above all, curious.'*

How can I prepare for my interview?

Be prepared to discuss:

- Your aspirations and ambitions for the future development of your art including the media and materials of art practice and what you hope to learn, understand and do while on the course

- The critical contexts of your present interests, such as the artists and ideas that have influenced and motivated you
- Your experience and understanding of the art that you have seen in exhibitions.

We would also like you to:

- Think about what you want to tell us during this discussion
- Think of any questions you want to ask us (please feel free to write these down and bring them with you).

 Reproduced with the kind permission of The Falmouth School of Art at Falmouth University www.falmouth.ac.uk

Checklist

- Visit exhibitions.
- Try to see the work of graduates from the art school, either at degree shows or online.
- Practise talking about your own work.
- Read the arts pages of national newspapers and magazines.
- Review your portfolio.
- Conduct a mock interview.
- Check the interview date, time and location.
- Find out how to get to your interview.

9 | Offers and what to do on results day

If you are lucky and receive an offer from a college or university, what do you do then? And if your offer depends on pending examination results, what happens when you receive the results? It depends on the type of course and the type of offer. The options are summarised below.

Foundation courses

In most cases you will receive an unconditional offer. In other words, the college has been convinced by your portfolio and interview, and it wants you. All you have to do then is to decide whether you want it! However, please note that in nearly all cases you will be expected to complete your current programme of study successfully.

In most cases, students are rejected for Foundation courses because their portfolios are not strong enough. Under these circumstances it is often possible to reapply once the portfolio has been strengthened.

Conditional offers

Under some circumstances you might be made a conditional offer. This normally happens because the college feels that while your work is promising you are not yet ready to cope with the demands of a Foundation course, or because it requires a particular A level grade or, as an overseas student, you would benefit from help with your language skills or with adapting to UK teaching methods in general. In this situation you may be asked to attend a summer course. (There is a charge for these courses.)

Accepting an offer

Since there is no centralised system for Foundation course applications (other than local schemes such as that run by the University of the Arts London), it is possible to hold a number of offers simultaneously. In this situation, the best strategy is to keep things simple, and not to try to juggle too many balls at one time. When you applied, you had probably

already decided which college was your first choice, which was second, and so on. If you are lucky enough to get offers from a number of colleges, stick to your original plan and accept the offer from the place where you most want to study. Do not accept offers from everyone just to keep your options open. Talk to your teachers or careers advisers if you are unsure about your best course of action.

What if you are rejected?

If you receive rejections, the first thing to do is to get feedback from the institution. If they reject you it is because they are not completely convinced that studying with them is the best option for you. This may be because they feel that your talents would be better directed towards a different course, discipline or environment. It might be because they think that you are not yet ready (creatively, technically or because of your age) to cope with their course. Once you understand why they are not able to offer you a place, you can focus on alternatives or aim to strengthen the areas that they were concerned about and then reapply. Remember that it is not the 'institution' that is rejecting you, it is someone with a creative or academic background who is looking to allocate the places on the course to the students who, in his or her opinion, would be most suited to that course. If you are rejected and have asked for feedback, then you have a number of options open to you.

- Accept one of the other offers that you may have.
- Make new applications to other art schools.
- Take on board their feedback and reapply once you have addressed their concerns. For example, enrol on some short courses or evening classes, or follow a one-year A level/pre-Foundation course.

Degree courses

You may receive an offer directly from the art school to which you have applied or, if you are applying through UCAS, you will (if all goes to plan) receive offers from more than one college. If you are lucky, these will be unconditional offers (this means that the offer does not depend on your achieving specific grades).

Conditional offers

If you receive a conditional offer, it will specify what the college requires of you – for instance, it may ask for a good grade in A level Art or, more commonly, good grades in other subjects, particularly if you are going to study for a joint honours degree.

Accepting an offer

When you have received replies from all of your five choices, you will (if you are lucky) be faced with a choice of institutions or courses. You will have to decide which course you want to hold as your firm choice (either conditional, CF, or unconditional, UF) and which you want as your insurance offer (either conditional, CI, or unconditional, UI). The insurance offer is usually a course that requires lower grades or marks than the firm choice. Once you have heard from all five choices, UCAS will send you a summary of their responses and give you a deadline (usually of about one month) in which to make the choice of the firm and insurance offers.

Clearing and Extra

If you are unsuccessful, either because you are not made any offers, or because you do not meet the conditions of your conditional offers, you are eligible to enter Clearing. The Clearing period begins in mid-August. This system means that you can contact other colleges and make new applications.

UCAS has also introduced a system called Extra. This starts in March, and allows candidates who are not holding any offers to approach other art schools. For details of both, look at the UCAS website.

Results day

If your offer for a place on a degree course depends on examination results (such as A levels, Scottish Highers or International Baccalaureate), then the day your results are issued can be a potentially stressful time. Even if you are confident that you have achieved the grades or scores that you need (and it is often easier for students studying art or design to have an idea of how they have done, since a proportion of the work for these subjects is marked internally by the school or college – but be warned: the marks your teachers submit to the examination boards can be moderated up or down), doing some preparation ahead of results day will make the whole experience less nerve-racking.

Preparation

- Have your UCAS candidate number and a copy of your UCAS form to hand.
- Make sure that you have uninterrupted access to the internet so that you can look at Clearing vacancies on the UCAS website.

- Make sure that your mobile phone is fully charged and you have topped up your credit, in case you need to call universities (you may have to call numerous times).

Summary of what to do on results day

You have the grades or scores that satisfy your conditional offer

You need to do nothing other than celebrate. The university will contact you over the following days to confirm your place and give you more information about practical details, for example when to arrive, what to bring, etc.

You have narrowly missed your offer

Log onto UCAS Track – you may still have been given your place. If not, you may have a place with your insurance choice. If in doubt, call the universities.

You have missed your offers, and this has been confirmed on UCAS Track

Use the Clearing lists to investigate other options. Call the universities' advertised Clearing hotlines and give them your UCAS number and the grades/scores that you achieved.

What to do if you do better than expected

If you are holding an offer and have achieved grades significantly better than you needed, then you can use the UCAS Adjustment scheme. For example, if your required grades were BCC but you actually achieved ABB, Adjustment allows you to look at courses at other universities that require higher grades. You have a window of one week to hold on to your original offer but also to pursue alternatives.

What to do if you do not get an offer

Four words: do not give up.

There are many options open to you. For degree applications, there are the Clearing and Extra systems (see above and www.ucas.com). For Foundation courses, you have the option of making direct contact with other colleges. You should also contact the colleges that rejected you to try to get their advice. It may be that they spotted a weakness in a particular area of your work and might be able to give you guidance on how to remedy this. If you can convince them that you desperately want to come to them and that you will work on that area – by taking evening classes, for example – they might allow you to bring in your updated portfolio later on in the year for reassessment.

If all else fails, you could consider taking a gap year during which you could work on your portfolio to strengthen it. Many colleges offer portfolio courses specifically for this purpose. These are generally part time and can be on a one-to-one basis or in small groups. In some cases, students are recommended to take a new A level (for example, in photography or textiles) and study this on a one-year part-time course, while using their spare time to gain work experience or to enrol on shorter courses that concentrate on, say, life drawing.

10| Fees and funding

If you are planning on studying at a college or university, you need to think about what it will cost you to do so. For some further education courses, UK students who are below an age threshold will not have to pay tuition fees, but in almost all circumstances you will need to pay for higher education and postgraduate courses.

UK and EU students

Foundation courses

Foundation courses are classed as further education courses, rather than higher education. For this reason, student loans are not available. However, students from the UK or the EU who are under 19 years old on 31 August in the year that the course starts are eligible for free tuition. Students who do not come into this category will have to pay tuition fees, which are likely to be about £1,000–£4,000 per year for UK/EU students.

Degree and HND courses

The government caps the fees for undergraduate courses for UK and EU students at up to £9,000 per year. Some universities charge the maximum fee but some offer courses for less than £9,000 a year. However, the fees do not have to be paid when you start the course – they are repaid through your tax code after you graduate, and only when you start earning £21,000 a year or more. The fees charged by each university can be found on their websites.

How much you will be asked to pay will depend on where you live and where you want to study. The diagram on page 90 summarises this.

Students who live in England will pay the full tuition fee (up to £9,000) wherever they study in the UK. Students resident in Scotland and who study in Scotland will not pay any tuition fees, but they will pay the full fee (up to £9,000) if they study anywhere else in the UK. Welsh students will pay up to the maximum fee wherever they study in the UK outside of Wales, or £3,810 if they study in Wales. Students from Northern Ireland will pay up to £9,000 if they study in England, Wales or Scotland, but they will pay only £3,805 if they study in Northern Ireland.

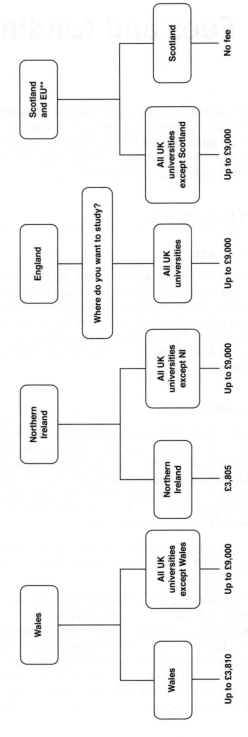

Where do you live?

Figure 4: Fees

**EU students pay the same as Welsh students if they go to a Welsh university

Full details and information on loans and grants can be found at www.gov.uk/browse/education/student-finance.

Postgraduate courses

There is no automatic right to funding or to student loans for this type of course. Students are often self-funding – or may be assisted by scholarships from universities or from other organisations. Contacting the institution to which you are applying is a good way to begin exploring your options. See Appendix 1 for telephone numbers, emails and web addresses.

Other sources of funding

Commercial organisations, charitable trusts, educational institutions and government agencies all offer sponsorship, special grants, access funds and scholarships, but these sources of finance are limited and hard to come by. If you are facing financial difficulties, a good place to start looking for information is the college to which you are applying. For example, Falmouth University offers a scholarship in memory of the artist Sandra Blow for a student enrolled on the MA in Fine Art: Contemporary Practice course. There are a number of similar sources of support available at institutions throughout the UK. You should look at the funding sections on the institutions' websites for further information. Remember that these scholarships vary in size and availability from year to year, so you should check the websites regularly for updates.

The Arts and Humanities Research Council (AHRC) also offers some funding for art and design students. Contact details can be found in Chapter 12 of this book.

For architecture students, RIBA offers a number of awards and scholarships to students in Part 1 or Part 2 studies (see page 38) and to graduates who are gaining more practical experience. The RIBA Hardship Funds are awarded to students who might not otherwise be able to study architecture or to continue their studies. RIBA also administers postgraduate scholarships, travel scholarships and research scholarships. Details can be found on the RIBA website.

Student loans

In addition to the new system of payment of tuition fees through loans, which are paid back once students have graduated and have reached a threshold of earnings (see page 89), loans are also available for UK students on higher education courses to help to pay for living costs during your studies. These are called maintenance loans. The amount you can borrow depends on where you study and where you live, up to a maximum of £8,200 per year. From September 2016, the maintenance

loan will be paid back in the same way as the tuition fees, that is, it will be taken as part of your tax code once you reach a threshold of earnings of £21,000 per year.

Contact details for the Student Loans Company (SLC) and for organisations that provide further information on student finance can be found in Chapter 12.

Non-EU international students

Fees for international students range from around £8,000 to £12,000 for Foundation courses, and between £10,000 and £16,000 per year for degree or postgraduate courses. Living costs could add an extra £10,000–£12,000 a year.

For international students postgraduate courses can sometimes be less expensive than degree courses. Check the institutions' websites for more information. US students may be able to get US federal or private loans. Further information on fees and funding can be found on the UKCISA website (see full contact details on page 98).

11 | Postgraduate courses

Having completed your degree, you can continue your studies, choosing from the wide variety of postgraduate courses that are available. Postgraduate courses allow you either to specialise in a particular field that interests you, or to reach a higher academic level to widen your job opportunities. Applications can be made either in the final year of your degree or after you have graduated and completed a period of professional practice.

Types of course

When considering whether or not to apply for postgraduate study, your first choice will be between a higher degree, diploma and certificate and between a taught and a research programme. Courses, which vary in structure, include one-, two- and three-year postgraduate degrees, leading, for example, to the award of a Master of Arts (MA), and postgraduate certificates that prepare students for specific professions, such as a Postgraduate Certificate in Animation, a Postgraduate Diploma in Museum Studies or a PGCE, the teaching qualification. You will also be able to develop a career in research, with a PhD or MPhil (see below for details) being the starting point.

Postgraduate courses are available at many colleges, art schools and universities. Many institutions offer courses at both undergraduate and postgraduate levels, making it possible to remain within the same institution for all your studies. There are also specialist schools of art such as the Royal College of Art and the Royal Academy Schools of Art which offer only postgraduate courses.

Master's degrees

Master's courses used to last for one year and the majority were organised as taught programmes. However, there are now numerous two-year courses. It is now also possible to do a master's degree by research – usually leading to a Master of Philosophy (or MPhil). This is a higher-level qualification than an MA but below that of a doctorate.

Taught master's degrees usually take from nine to 12 months (or two years if you are a part-time student). The first six to nine months are

usually studio and classroom based, and are followed by time spent on a research project.

Doctorates

A Doctor of Philosophy (PhD) is always achieved by research under the guidance of a supervisor – a member of academic staff who shares your interest and is an expert in that particular area. Your area of study will be highly specialised and you will have to submit a thesis – of up to 100,000 words – based on original research. A PhD typically takes four years (but can take longer).

Courses cover the full range of art and design disciplines and, while it is usual to continue working within the same area of study that you have followed at undergraduate level, it is also possible to cross over into other areas.

Applying for a postgraduate course

There is no centralised system like UCAS for postgraduate courses, nor is there a set closing date. UCAS does have a postrgraduate application system, UKPASS, but not all universities are represented. Details can be found on the UCAS website. Some taught programmes have deadlines, but it is often possible to begin a research programme at different points during the academic year. There may, in fact, be different starting dates throughout the year for all types of courses – but the autumn term is still the most popular. There is no limit to the number of applications that you may make, but most students make a maximum of six applications and on average around two to three.

Application procedures vary, but in the first instance you should refer to the college at which you intend to study. You will be required to submit a portfolio, attend an interview and, in some cases, present a formal proposal of an intended programme of study. Take a look at the comments below from Andrew Watson to get an idea of how one college approaches the admissions process.

> ### WARNING!
>
> Funding for these courses is often even harder won than the places gained on them. Chapter 10 has information on fees for postgraduate courses. Contacting the institution to which you are applying is a good way to begin exploring your options. See Appendix 1 for email addresses and telephone numbers.

'Postgraduate courses have well-defined portfolio requirements. These will vary in relation to the level of postgraduate study (Postgraduate Certificate, Postgraduate Diploma and MA) and in relation to the subject area (design, art, media). Start by checking the published portfolio requirements for the course you are applying to. The portfolio is used as a means of assessing an applicant's suitability for the level of study and their motivation and potential to achieve the course aims and learning outcomes. At postgraduate level you should be able to demonstrate intelligence and maturity of approach to a personal area of interest as well as confidence in the abilities that you will require to explore a range of technical and formal problems. You should also emphasise your ability to undertake independent research. For design-based studies it is important to show that you can produce, communicate and evaluate a range of ideas and design responses to a particular problem. MA applicants should be able to show critical and analytical abilities and evidence of original thinking. Fine art and media courses would expect the applicant to be able to show, either at interview or in an accompanying statement, an awareness of the cultural and social context of the work submitted in the portfolio.

'Many courses now limit the quantity and form of the work submitted at application and ask for additional examples to be shown at interview. Again, it is very important to check specific published course requirements on this.'

Andrew Watson, Course Director for the
Postgraduate Certificate in Professional Studies in
Art and Design, Central St Martins

Advice on choosing and applying for postgraduate courses

- Have a clear idea of what you want to achieve by enrolling on a postgraduate course: are you aiming to develop your practice in a more general way, or are you looking to specialise in a particular area within your chosen field? You will need to decide what you want the outcome to be before choosing which courses to apply for.
- If you are thinking about postgraduate courses because you want to teach within a college or university environment, talk to teachers or lecturers about which courses are most appropriate.
- Many postgraduate students choose their courses because they want to work within a specialised field. For example, by specialising in documentary photography having completed a BA in Photography. Try to find out where graduates from your chosen course end up working, and make sure that your own career plans can be realised by taking the course.
- Talk to the course director before making a final decision to find out what type of students follow the course. Are they recent graduates,

or industry professionals looking to extend their skills? Will there be other students with the same experience, qualifications or goals as you?

- Do as much research as you can on who will be teaching you and who will be interviewing you, so that you can tailor your portfolio appropriately.

12| Further information

Applications

Degree courses

UCAS
Rosehill
New Barn Lane
Cheltenham
GL52 3LZ
Tel: 01242 222444
www.ucas.com

University of Cambridge
Admissions Office
University of Cambridge
Fitzwilliam House
32 Trumpington Street
Cambridge
CB2 1QY
Tel: 01223 333308
www.cam.ac.uk

University of Oxford
Undergraduate Admissions Office
University Offices
Wellington Square
Oxford
OX1 2JD
Tel: 01865 288000
www.ox.ac.uk

Books

HEAP 2017: University Degree Course Offers: The Essential Guide to Winning Your Place at University, Brian Heap (Trotman Education)

How to Complete Your UCAS Application: 2017 Entry, Beryl Dixon (Trotman Education)

Funding

UCAS student finance information
www.ucas.com/ucas/undergraduate/finance-and-support

Student Loans Company (SLC)
Tel: 0300 100 0607
www.slc.co.uk

Arts and Humanities Research Council (AHRC)
www.ahrc.ac.uk/funding/opportunities/current

International students

British Council
www.britishcouncil.org

English UK
www.englishuk.com

UK Council for International Student Affairs (UKCISA)
www.ukcisa.org.uk

International English Language Testing System (IELTS)
www.ielts.org

Test of English as a Foreign Language (TOEFL)
www.ets.org/toefl

Art and design bodies

Arts councils

Arts Council England
21 Bloomsbury Street
London
WC1B 3HF
www.artscouncil.org.uk

Arts Council of Wales
Bute Place
Cardiff
CF10 5AL
www.artswales.org.uk

Arts Council of Northern Ireland
77 Malone Road
Belfast

BT9 6AQ
www.artscouncil-ni.org

Creative Scotland
Waverley Gate
2–4 Waterloo Place
Edinburgh
EH1 3EG
www.creativescotland.com

Professional bodies

The Association of Photographers
Studio 9
Holborn Studios
49/50 Eagle Wharf Road
London
N1 7ED
www.the-aop.org

British Film Institute
21 Stephen Street
London
W1T 1LN
www.bfi.org.uk

Crafts Council
44a Pentonville Road
London
N1 9BY
www.craftscouncil.org.uk

Design Council
Angel Building
London
EC1V 4AB
www.designcouncil.org.uk

Printmakers Council
Ground Floor Unit
23 Blue Anchor Lane
London
SE16 3UL
www.printmakerscouncil.com

Architecture

Architects Registration Board
8 Weymouth Street
London
W1W 5BU
www.arb.org.uk

Royal Institute of British Architects (RIBA)
66 Portland Place
London
W1B 1AD
www.architecture.com

The RIBA President's Medals Student Awards
For degree courses in architecture and examples of students' work, see www.presidentsmedals.com

Reading List

The art schools' and universities' websites and brochures often highlight books that they recommend for students. As you will see if you go to online booksellers or visit good bookshops, there are many thousands of books about art, architecture or design. So, where do you start? The following titles are my personal favourites:

What Are You Looking At?: 150 Years of Modern Art in the Blink of an Eye, Will Gompertz (Viking)

Seven Days in the Art World, Sarah Thornton (Granta Books)

How to Read Paintings, Liz Rideal (Bloomsbury Visual Arts)

The Story of Architecture, Jonathan Glancey (Dorling Kindersley)

Modernism, Richard Weston (Phaidon Press)

A Cultural History of Fashion in the 20th and 21st Centuries, Bonnie English (Bloomsbury Academic)

Photography: A Concise History, Ian Jeffrey (Thames & Hudson)

Art Photography Now, Susan Bright (Thames & Hudson)

The Pot Book, Edmund de Waal and Claudia Clare (Phaidon Press)

The Craftsman, Richard Sennett (Penguin)

Graphic Design Visionaries, Caroline Roberts (Laurence King)

Magazines

This list only scrapes the surface of the publications available. The best places to look for art and design magazines are museum and gallery bookshops, which carry wide selections.

Architects' Journal
Architectural Review
Art Monthly
Artist Portfolio Magazine
ArtReview
B&W (photography)
Blueprint (design)
British Journal of Photography
Ceramic Review

Ceramics Monthly
Computer Arts Magazine
Creative Review
Frieze
IMA Magazine (Photography)
Modern Painters
Next Level
Photography Monthly
TATE ETC.

Websites

The web's shifting landscape means that new sites devoted to art and design appear on a daily basis. We have listed some interesting sites below, but you should also do your own searching when you have free time. Searching for 'art magazine online', for example, will give you over a million starting points.

Aesthetica art magazine – www.aestheticamagazine.com
A List Apart (web design) – www.alistapart.com
AntiDull Magazine – www.antidull.com
ArtistPortfolio – www.artistportfolio.net
Artnet – www.artnet.com
Arts Council media channel – www.artscouncil.org.uk/channel
British Arts – www.britisharts.co.uk
Flash Art – www.flashartonline.com
Juxtapoz Art & Culture Magazine – www.juxtapoz.com
NY Arts – www.nyartsmagazine.com
Printmakers' resources and links – www.printmaker.co.uk/links.html
Saatchi Gallery (links to other resources) – www.saatchi-gallery.com
Tate Collection – www.tate.org.uk/art/

Artists' websites

Ralph Kiggell: www.ralphkiggell.com
Akiko Hirai: www.akikohiraiceramics.com
Harriet Blomefield: www.harrietblomefield.co.uk

Appendix 1: Institution contact details

Aberystwyth University
Tel: 01970 623111
Email: ug-admissions@aber.ac.uk
www.aber.ac.uk

Accrington & Rossendale College
Tel: 01254 354117
Email: he@accross.ac.uk
www.accross.ac.uk/
higher-education

Activate Learning (Oxford, Reading, Banbury & Bicester)
Tel: 01865 551691
Email: HE@activatelearning.ac.uk
www.activatelearning.ac.uk

Amersham & Wycombe College
Tel: 01494 585555
Email: info@amersham.ac.uk
www.amersham.ac.uk

Anglia Ruskin University
Tel: 01245 686868
Email: answers@anglia.ac.uk
www.anglia.ac.uk

University of the Arts London
Email: ucas.enquiries@arts.ac.uk
www.arts.ac.uk

Arts University Bournemouth
Tel: 01202 363228
Email: admissions@aub.ac.uk
www.aub.ac.uk

Bangor University
Tel: 01248 383717
Email: admissions@bangor.ac.uk
www.bangor.ac.uk

Barking and Dagenham College
Tel: 020 3667 0265
Email: admissions@bdc.ac.uk
www.barkingdagenhamcollege.
ac.uk

Barnet and Southgate College
Tel: 020 8266 4108
Email: geraldine.murphy@
barnetsouthgate.ac.uk
www.barnetsouthgate.ac.uk

Barnfield College, Luton
Tel: 01582 569819
Email: dave.malachi@barnfield.
ac.uk
www.barnfield.ac.uk

Barnsley College
Tel: 01226 216215
Email: info@barnsley.ac.uk
www.universitycampus.barnsley.
ac.uk

Basingstoke College of Technology
Tel: 01256 354141
Email: admissions@bcot.ac.uk
www.bcot.ac.uk

University of Bath
Tel: 01225 383019
Email: admissions@bath.ac.uk
www.bath.ac.uk/admissions

Bath College
Tel: 01225 312191
Email: enquiries@citybathcoll.ac.uk
www.citybathcoll.ac.uk

Bath Spa University
Tel: 01225 875875
Email: enquiries@bathspa.ac.uk
www.bathspa.ac.uk

Bedford College
Tel: 01234 291000
Email: info@bedford.ac.uk
www.bedford.ac.uk

University of Bedfordshire
Tel: 01582 743500
Email: admission@beds.ac.uk
www.beds.ac.uk

Bexley College
Tel: 01322 404000
Email: info@bexley.ac.uk
www.bexley.ac.uk

Birmingham City University
Tel: 0121 331 5595
www.bcu.ac.uk

Birmingham Metropolitan College
Tel: 0121 446 4545
Email: heenquiries@bmetc.ac.uk
www.bmetc.ac.uk

Bishop Burton College
Tel: 01964 553000
Email: enquiries@bishopburton.ac.uk
www.bishopburton.ac.uk

Blackburn College
Tel: 01254 292594
Email: he-admissions@blackburn.ac.uk
www.blackburn.ac.uk

Blackpool and The Fylde College
Tel: 01253 504322
Email: admissions@blackpool.ac.uk
www.blackpool.ac.uk

University of Bolton
Tel: 01204 903903
Email: enquiries@bolton.ac.uk
www.bolton.ac.uk

Bournemouth and Poole College
Tel: 01202 205180
Email: heunit@bpc.ac.uk
www.thecollege.co.uk

Bournemouth University
Tel: 01202 961916
Email: askBUenquiries@bournemouth.ac.uk
www.bournemouth.ac.uk

Bournville College
Tel: 0121 477 1300
Email: info@bournville.ac.uk
www.bournville.ac.uk

Bradford College
Tel: 01274 433008
Email: registrarservices@bradfordcollege.ac.uk
www.bradfordcollege.ac.uk/university-centre

Bridgend College
Tel: 01656 302251
Email: heenquiries@bridgend.ac.uk
www.bridgend.ac.uk

University of Brighton
Tel: 01273 644644
Email: admissions@brighton.ac.uk
www.brighton.ac.uk

City of Bristol College
Tel: 0117 312 5143
Email: caroline.coombs
@cityofbristol.ac.uk
www.cityofbristol.ac.uk

Brunel University London
Tel: 01895 265265
www.brunel.ac.uk

The University of Buckingham
Tel: 01280 820313
Email: admissions@buckingham.
ac.uk
www.buckingham.ac.uk

Buckinghamshire New University
Tel: 0330 123 2023
Email: admissions@bucks.ac.uk
www.bucks.ac.uk/clearing

Bury College
Tel: 0161 280 8280
Email: information@burycollege.
ac.uk
www.burycollege.ac.uk

Calderdale College
Tel: 01422 399316
Email: admissions@calderdale.
ac.uk
www.calderdale.ac.uk

University of Cambridge
Tel: 01223 333 308
Email: admissions@cam.ac.uk
www.study.cam.ac.uk/
undergraduate

Cambridge School of Visual & Performing Arts
Tel: 01223 345698
Email: admissions@csvpa.com
www.csvpa.com

Canterbury Christ Church University
Tel: 01227 782900
Email: admissions@canterbury.
ac.uk
www.canterbury.ac.uk

Canterbury College
Tel: 01227 811111
Email: headmissions@
canterburycollege.ac.uk
www.canterburycollege.ac.uk

Cardiff University
Tel: 029 2087 9999
Email: admissions@cardiff.ac.uk
www.cardiff.ac.uk

Cardiff Metropolitan University
Tel: 029 2041 6070
Email: admissions@cardiffmet.
ac.uk
www.cardiffmet.ac.uk

Carshalton College
Tel: 020 8544 4530
Email: Timothy.Ellison@carshalton.
ac.uk
www.carshalton.ac.uk

University of Chester
Tel: 01244 511000
Email: enquiries@chester.ac.uk
www.chester.ac.uk

Chesterfield College
Tel: 01246 500500
Email: advice@chesterfield.ac.uk
www.chesterfield.ac.uk

University of Chichester
Tel: 01243 816002
Email: admissions@chi.ac.uk
www.chi.ac.uk

Chichester College
Tel: 01243 786321 – 2112
Email: generalenquiries
@chichester.ac.uk
www.chichester.ac.uk

**City and Islington College
(London)**
Tel: 020 7700 9200
Email: Clearing2@candi.ac.uk
www.candi.ac.uk/higher-education

City College Brighton & Hove
Tel: 01273 667719
Email: HE@ccb.ac.uk
www.ccb.ac.uk

City College Plymouth
Tel: 01752 305786
Email: he@cityplym.ac.uk
www.cityplym.ac.uk/university-
level-courses

City of Glasgow College
Tel: 0141 566 6222
www.cityofglasgowcollege.ac.uk

The City of Liverpool College
Tel: 0151 2521515
Email: enquiry@liv-coll.ac.uk
www.liv-coll.ac.uk

City of Westminster College
Tel: 020 7258 2721
Email: customer.services
@cwc.ac.uk
www.cwc.ac.uk

City of Wolverhampton College
Tel: 01902 317587
Email: urkovskisr@wolvcoll.ac.uk
www.wolvcoll.ac.uk

**Cleveland College of Art and
Design**
Tel: 01642 288888
Email: studentrecruitment@ccad.
ac.uk
www.ccad.ac.uk

Colchester Institute
Tel: 01206 712777
Email: info@colchester.ac.uk
www.colchester.ac.uk

Cornwall College
Tel: 01209 617698
Email: uni@cornwall.ac.uk
www.cornwall.ac.uk

Coventry University
Tel: 024 7765 2222
Email: studentenquiries@
coventry.ac.uk
www.coventry.ac.uk

Craven College
Tel: 01756 791411
Email: enquiries@craven-college.
ac.uk
www.craven-college.ac.uk

**University for the Creative Arts
(UCA)**
Tel: 01252 892960
Email: admissions@ucreative.
ac.uk
www.ucreative@ac.uk

Croydon College
Tel: 020 8760 5934
Email: admissions@croydon.ac.uk
www.croydon.ac.uk

University of Cumbria
Tel: 0845 606 1144
Email: enquirycentre@cumbria.
ac.uk
www.cumbria.ac.uk

**De Montfort University
(Leicester)**
Tel: 0116 250 60 70
Email: enquiry@dmu.ac.uk
www.dmu.ac.uk

University of Derby
Tel: 01332 591167
Email: askadmissions@derby.ac.uk
www.derby.ac.uk

Doncaster College
Tel: 0800 358 7474
Email: he@don.ac.uk
www.don.ac.uk/uc

Dudley College of Technology
Tel: 01384 363277/6
Email: admissions@dudleycol.
ac.uk
www.dudleycol.ac.uk

University of Dundee
Tel: 01382 383838
www.dundee.ac.uk/study/ug

**Ealing, Hammersmith and West
London College**
Tel: 020 7565 1234
Email: admissions@wlc.ac.uk
www.wlc.ac.uk

University of East Anglia (UEA)
Tel: 01603 591515
Email: admissions@uea.ac.uk
www.uea.ac.uk

University of East London (UEL)
Tel: 020 8223 3333
Email: study@uel.ac.uk
www.uel.ac.uk

East Riding College
Tel: 0345 120 0044
Email: admissions@
eastridingcollege.ac.uk
www.eastridingcollege.ac.uk

East Surrey College
Tel: 01737 788486
Email: hashton@esc.ac.uk
www.esc.ac.uk

The University of Edinburgh
Tel: 0131 650 4360
Email: sra.enquiries@ed.ac.uk
www.ed.ac.uk/studying/
undergraduate

Edinburgh Napier University
Tel: 0333 900 6040
Email: studentrecruitment@napier.
ac.uk
www.napier.ac.uk

Exeter College
Tel: 0845 111 6000
Email: info@exe-coll.ac.uk
www.exe-coll.ac.uk/he

Falmouth University
Tel: 01326 213730
Email: admissions@falmouth.ac.uk
www.falmouth.ac.uk/admissions

University Centre Farnborough
Tel: 01252 407028
Email: admissions@farn-ct.ac.uk
www.farn-ct.ac.uk

Furness College
Tel: 01229 844758
Email: louise.ducie@furness.ac.uk
www.furness.ac.uk

Gateshead College
Tel: 0191 490 2245
Email: HE.Admissions@
gateshead.ac.uk
www.gateshead.ac.uk

Glasgow Caledonian University
Tel: 0141 331 8630
Email: studentenquiries@gcu.ac.uk
www.gcu.ac.uk

The Glasgow School of Art
Tel: 0141 353 4434/4514
Email: admissions@gsa.ac.uk
www.gsa.ac.uk

The University of Gloucestershire
Tel: 01242 714501
Email: admissions@glos.ac.uk
www.glos.ac.uk

Gloucestershire College
Tel: 0345 155 2020
Email: info@gloscol.ac.uk
www.gloscol.ac.uk

Glyndwr University
Tel: 01978 293439
Email: enquiries@glyndwr.ac.uk
www.glyndwr.ac.uk

Goldsmiths, University of London
Tel: 020 7078 5300
Email: admissions@gold.ac.uk
www.gold.ac.uk

Gower College Swansea
Tel: 01792 284179
Email: fiona.john@
gowercollegeswansea.ac.uk
www.gowercollegeswansea.ac.uk

University of Greenwich
Tel: 020 8331 9000
Email: courseinfo@gre.ac.uk
www.gre.ac.uk

University Centre Grimsby
Tel: 0800 328 3631
Email: headmissions@grimsby.
ac.uk
www.grimsby.ac.uk

Guildford College
Tel: 01483 448500
Email: he@guildford.ac.uk
www.guildford.ac.uk/Guildford
College/HigherEducation

Harrogate College
Tel: 01423 878355
Email: oncourse@harrogate.ac.uk
www.harrogate.ac.uk

Havering College of Further and Higher Education
Tel: 01708 462801
Email: information@havering-
college.ac.uk
www.havering-college.ac.uk

Heart of Worcestershire College
Tel: 01905 743463
www.howcollege.ac.uk

Henley College Coventry
Tel: 024 7662 6300
Email: mcrompton@henley-cov.
ac.uk
www.henley-cov.ac.uk

Hereford College of Arts
Tel: 01432 273359
Email: headmin@hca.ac.uk
www.hca.ac.uk

Heriot-Watt University, Edinburgh
Tel: 0131 451 3376
Email: ugadmissions@hw.ac.uk
www.hw.ac.uk

University of Hertfordshire
Tel: 01707 284800
Email: ask@herts.ac.uk
www.herts.ac.uk

University of the Highlands and Islands
Tel: 0845 2723600
Email: info@uhi.ac.uk
www.uhi.ac.uk

The University of Huddersfield
Tel: 01484 473969
Email: aro@hud.ac.uk
www.hud.ac.uk

Hugh Baird College
Tel: 0151 353 4654
Email: admissions@hughbaird.ac.uk
www.hughbaird.ac.uk/index.php/
university-centre

The University of Hull
Tel: 01482 466100
Email: admissions@hull.ac.uk
www.hull.ac.uk

Hull College
Tel: 01482 329943
Email: info@hull-college.ac.uk
www.hull-college.ac.uk/HE

Kensington and Chelsea College
Tel: 020 7573 3600
Email: enquiries@kcc.ac.uk
www.kcc.ac.uk

The University of Kent
Tel: 01227 827272
Email: information@kent.ac.uk
www.kent.ac.uk

Kingston College
Tel: 020 8268 2969
Email: student.services@
kingston-college.ac.uk.
www.kingston-college.ac.uk

Kingston University
Tel: 0844 855 217
Email: aps@kingston.ac.uk
www.kingston.ac.uk

Kirklees College
Tel: 01484 437033
Email: heapplications@
kirkleescollege.ac.uk
www.kirkleescollege.ac.uk

KLC School of Design (London)
Tel: 020 7376 3377
Email: info@klc.co.uk
www.klc.co.uk

Lakes College – West Cumbria
Tel: 01946 839300
Email: student.services@lcwc.ac.uk
www.lcwc.ac.uk

University of Central Lancashire (UCLan)
Tel: 01772 892444
Email: uadmissions@uclan.ac.uk
www.uclan.ac.uk

Lancaster University
Tel: 01524 592028
Email: ugadmissions@lancaster.
ac.uk
www.lancaster.ac.uk

University of Leeds
Tel: 0113 343 2336
Email: study@leeds.ac.uk
www.leeds.ac.uk/undergraduate

Leeds Beckett University
Tel: 0113 812 3113
Email: admissionenquiries@
leedsbeckett.ac.uk
www.leedsbeckett.ac.uk

Leeds City College
Tel: 0113 216 2406
Email: headmissions@
leedscitycollege.ac.uk
www.leedscitycollege.ac.uk

Leeds College of Art
0113 202 8000
Email: info@leeds-art.ac.uk
www.leeds-art.ac.uk

Leeds College of Building
Tel: 0113 222 6002
Email: info@lcb.ac.uk
www.lcb.ac.uk

University of Leicester
Tel: 0116 252 5281
Email: admissions@le.ac.uk
www.le.ac.uk

Leicester College
Tel: 0116 224 2240
Email: info@leicestercollege.ac.uk
www.leicestercollege.ac.uk

Lewisham Southwark College
Tel: 020 3757 3545
mariyana.gavrilova@lesoco.ac.uk
www.lesoco.ac.uk

University of Lincoln
Tel: 01522 886644
www.lincoln.ac.uk/home/contacts

Lincoln College
Tel: 01522 876000
Email: enquiries@lincolncollege.
ac.uk
www.lincolncollege.ac.uk

University of Liverpool
Tel: 0151 794 5927
Email: ugrecruitment@liv.ac.uk
www.liv.ac.uk

Liverpool Hope University
Tel: 0151 291 3111
Email: enquiry@hope.ac.uk
www.hope.ac.uk

The Liverpool Institute for Performing Arts
Tel: 0151 330 3000
Email: admissions@lipa.ac.uk
www.lipa.ac.uk

Liverpool John Moores University (LJMU)
Tel: 0151 231 5090
Email: courses@ljmu.ac.uk
www.ljmu.ac.uk

Coleg Llandrillo
Tel: 01492 542338
Email: degrees.llandrillo@gllm.
ac.uk
www.gllm.ac.uk/degrees

ARU London (LCA Business School)
Tel: 020 7400 6784
Email: ucas@lca.anglia.ac.uk
www.lca.anglia.ac.uk

The London College, UCK
Tel: 020 7243 4000
Email: admissions@lcuck.ac.uk
www.lcuck.ac.uk

London Metropolitan University
Tel: 020 7133 4200
Email: admissions@londonmet.
ac.uk
www.londonmet.ac.uk

London South Bank University
Tel: 0800 923 8888
Email: course.enquiry@lsbu.ac.uk
www.lsbu.ac.uk

Loughborough University
Tel: 01509 274403
Email: admissions@lboro.ac.uk
www.lboro.ac.uk

The University of Manchester
Tel: 0161 275 2077
Email: ug-admissions@
manchester.ac.uk
www.manchester.ac.uk

The Manchester College
Tel: 0161 203 2100
Email: enquiries@
themanchestercollege.ac.uk
www.themanchestercollege.ac.uk

Manchester Metropolitan University
Tel: 0161 247 6969
www.mmu.ac.uk

Coleg Menai
Tel: 01248 370125
Email: student.services@menai.
ac.uk
www.menai.ac.uk

Mid Cheshire College
Tel: 01606 720558
Email: eandrews@midchesh.
ac.uk
www.midchesh.ac.uk/HE

Middlesex University
Tel: 020 8411 5555
Email: enquiries@mdx.ac.uk
www.mdx.ac.uk

Milton Keynes College
Tel: 01908 684452
Email: info@mkcollege.ac.uk
www.mkcollege.ac.uk

Mont Rose College
Tel: 020 8556 5009
Email: admissions@mrcollege.
ac.uk
www.mrcollege.ac.uk

Newcastle College
Tel: 0191 200 4613/4110
Email: ucas@ncl-coll.ac.uk
www.newcastlecollege.co.uk

Newcastle University
Tel: 0191 208 3333
www.ncl.ac.uk

New College Durham
Tel: 0191 375 4210
Email: admissions@newdur.
ac.uk
www.newcollegedurham.ac.uk

**New College of the
Humanities**
Tel: 020 7637 4550
Email: admissions@nchum.org
www.nchlondon.ac.uk

New College Nottingham
Tel: 0115 910 0100 – 7517
Email: he.team@ncn.ac.uk
www.ncn.ac.uk

New College Stamford
Tel: 01780 484334
Email: enquiries@stamford.ac.uk
www.stamford.ac.uk

North Lindsey College
Tel: 01724 294125
Email: he@northlindsey.ac.uk
www.northlindsey.ac.uk

**North Warwickshire and
Hinckley College**
Tel: 024 7624 3395
Email: angela.jones@nwhc.ac.uk
www.nwhc.ac.uk

University of Northampton
Tel: 0800 358 2232
Email: admissions@northampton.
ac.uk
www.northampton.ac.uk

Northbrook College Sussex
Tel: 0845 155 6060
Email: enquiries@nbcol.ac.uk
www.northbrook.ac.uk

Northumberland College
Tel: 01670 841200
Email: advice.centre@northland.
ac.uk
www.northumberland.ac.uk

Northumbria University
Tel: 0191 406 0901
Email: er.admissions@northum-
bria.ac.uk
www.northumbria.ac.uk

Norwich University of The Arts
Tel: 01603 886389
Email: admissions@nuca.ac.uk
www.nua.ac.uk

Central College Nottingham
Tel: 0115 884 2538
Email: he.enquiries@
centralnottingham.ac.uk
www.centralnottingham.ac.uk

The University of Nottingham
Tel: 0115 951 5151
www.nottingham.ac.uk

Nottingham Trent University
Tel: 0115 848 4200
www.ntu.ac.uk

Oaklands College
Tel: 01727 737000
www.oaklands.ac.uk

University Campus Oldham
Tel: 0161 344 8800
Email: info@uco.oldham.ac.uk
www.uco.oldham.ac.uk

Oxford Brookes University
Tel: 01865 483040
Email: admissions@brookes.ac.uk
www.brookes.ac.uk

Oxford University
Tel: 01865 288000
Email: study@ox.ac.uk
www.ox.ac.uk/apply

Pearson College
Tel: 0203 441 1303
Email: pearsondegrees@pearson.com
www.pearsoncollege.com

Petroc
Tel: 01271 852335
Email: emma.gilroy@petroc.ac.uk
www.petroc.ac.uk

Plumpton College
Tel: 01273 892082
Email: admissions@plumpton.ac.uk
www.plumpton.ac.uk

Plymouth College of Art
Tel: 01752 203434
Email: admissions@pca.ac.uk
www.plymouthart.ac.uk

Plymouth University
Tel: 01752 585858
Email: admissions@plymouth.ac.uk
www.plymouth.ac.uk

University of Portsmouth
Tel: 023 9284 5566
Email: admissions@port.ac.uk
www.port.ac.uk

Queen's University Belfast
Tel: 028 9097 3838
Email: admissions@qub.ac.uk
www.qub.ac.uk

Queen Mary University of London
Tel: 020 7882 5511
Email: admissions@qmul.ac.uk
www.qmul.ac.uk

Ravensbourne
Tel: 020 3040 3500
Email: info@rave.ac.uk
www.ravensbourne.ac.uk

University of Reading
Tel: 0118 378 8372
Email: ugadmissions@reading.ac.uk
www.reading.ac.uk

Regent's University London
Tel: 020 7487 7505
Email: exrel@regents.ac.uk
www.regents.ac.uk

Robert Gordon University
Tel: 01224 262728
Email: ugoffice@rgu.ac.uk
www.rgu.ac.uk

University of Roehampton
Tel: 020 8392 3232
Email: enquiries@roehampton.ac.uk
www.roehampton.ac.uk

Rose Bruford College
Tel: 0208 308 2600
Email: enquiries@bruford.ac.uk
www.bruford.ac.uk

Rotherham College of Arts and Technology
Tel: 01709 722777
Email: info@rotherham.ac.uk
www.rotherham.ac.uk

The Royal Central School of Speech and Drama, University of London
Tel: 0207 722 8183
Email: admissions@cssd.ac.uk
www.cssd.ac.uk

Royal Conservatoire of Scotland
Tel: 0141 332 4101
Email: registry@rcs.ac.uk
www.rcs.ac.uk

Runshaw College
Tel: 01772 642040
Email: ucr@runshaw.ac.uk
www.runshaw.ac.uk/
university-courses

Ruskin College Oxford
Tel: 01865 759604
Email: enquiries@ruskin.ac.uk
www.ruskin.ac.uk

SAE Institute
Tel: 03330 112315
Email: ukadmissions@sae.edu
www.uk.sae.edu

The University of Salford
Tel: 0161 295 5000
Email: course-enquiries@salford.ac.uk
www.salford.ac.uk

Selby College
Tel: 01757 211062
Email: info@selby.ac.uk
www.selby.ac.uk

The University of Sheffield
Tel: 0114 222 8030
www.sheffield.ac.uk

Sheffield College
Tel: 0114 260 2597
Email: heunit@sheffcol.ac.uk
www.sheffcol.ac.uk

Sheffield Hallam University
Tel: 0114 225 5555
Email: admissions@shu.ac.uk
www.shu.ac.uk

Shrewsbury College of Arts and Technology
Email: higher@shrewsbury.ac.uk
www.shrewsbury.ac.uk

Coleg Sir Gâr/Carmarthenshire College
Tel: 01554 748000
Email: admissions@colegsirgar.ac.uk
www.colegsirgar.ac.uk

Solihull College
Tel: 0121 678 7000
Email: enquiries@solihull.ac.uk
www.solihull.ac.uk

Somerset College
Tel: 01823 366331
Email: enquiries@somerset.ac.uk
www.somerset.ac.uk/student-area/considering-a-degree

University of Southampton
Tel: 023 8059 5000
Email: admissions@soton.ac.uk
www.southampton.ac.uk

Southampton Solent University
Tel: 023 8201 5066
Email: admissions@solent.
ac.uk
www.solent.ac.uk

**South & City College
Birmingham**
Tel: 0800 111 6311
Email: hello@southandcity.com
www.sccb.ac.uk

South Devon College
Tel: 01803 540790
Email: awilson@southdevon.ac.uk
www.southdevon.ac.uk

**South Essex College, University
Centre Southend and Thurrock**
Tel: 01702 220664
Email: HEadmissions@
southessex.ac.uk
www.southessex.ac.uk

**South Gloucestershire and
Stroud College**
Tel: 01179 152412
Email: matthew.payne@sgscol.
ac.uk
www.sgscol.ac.uk

South Leicestershire College
Tel: 0116 264 3535
Email: jackie.branson@slcollege.
ac.uk
www.slcollege.ac.uk

South Thames College
Tel: 020 8918 7205
Email: info@south-thames.ac.uk
www.south-thames.ac.uk

South Tyneside College
Tel: 0191 427 3900
Email: student.services@stc.
ac.uk
www.stc.ac.uk

Southport College
Tel: 01704 500606
www.southport.ac.uk

University of South Wales
Tel: 03455 767778
Email: enquiries@southwales.
ac.uk
www.southwales.ac.uk

Spurgeon's College
Tel: 020 8653 0850
Email: admissions@spurgeons.
ac.uk
www.spurgeons.ac.uk

Staffordshire University
Tel: 01782 294400
Email: enquiries@staffs.ac.uk
www.staffs.ac.uk

Stockport College
Tel: 0161 296 5649
Email: sheila.morris@stockport.
ac.uk
www.stockport.ac.uk

University Centre St Helens
Tel: 01744 733766
Email: enquire@sthelens.ac.uk
www.sthelens.ac.uk

The University of Strathclyde
Tel: 0141 548 3195
Email: admissions@strath.ac.uk
www.strath.ac.uk

University Campus Suffolk (UCS)
Tel: 01473 338833
Email: infozone@ucs.ac.uk
www.ucs.ac.uk

Sunderland College
Tel: 0191 511 6000
Email: info@sunderlandcollege.
ac.uk
www.sunderlandcollege.ac.uk

University of Sunderland
Tel: 0191 515 3000
Email: student.helpline@
sunderland.ac.uk
www.sunderland.ac.uk

University of Surrey
Tel: 01483 682222
Email: admissions@surrey.ac.uk
www.surrey.ac.uk

Sussex Downs College
Tel: 01323 637655
Email: he@sussexdowns.ac.uk
www.sussexdowns.ac.uk/
colleges/higher-education-
college

Swindon College
Tel: 01793 491591
Email: angelasinclair@swindon.
ac.uk
www.swindon.ac.uk

Teesside University
Tel: 01642 218121
Email: registry@tees.ac.uk
www.tees.ac.uk

**Tresham College of Further and
Higher Education**
Tel: 0345 658 8990
Email: info@tresham.ac.uk
www.tresham.ac.uk

Truro and Penwith College
Tel: 01872 267122
Email: HEenquiry@truro-penwith.
ac.uk
www.truro-penwith.ac.uk

Tyne Metropolitan College
Tel: 0191 229 5000
Email: enquiries@tynemet.
ac.uk
www.tynemet.ac.uk

**UCL (University College
London)**
Tel: 020 7679 3000
Email: undergraduate-
admissions@ucl.ac.uk
www.ucl.ac.uk

Ulster University
Tel: 028 7012 4221
Email: online@ulster.ac.uk
www.ulster.ac.uk

Wakefield College
Tel: 01924 789803
Email: c.jordan@wakefield.ac.uk
www.wakefield.ac.uk/
highereducation

**University of Wales Trinity
St David (UWTSD Carmarthen/
Lampeter)**
Tel: 01267 676767
Email: admissions@uwtsd.ac.uk
www.uwtsd.ac.uk

**University of Wales Trinity
St David (UWTSD Swansea)**
Tel: 01792 481000
Email: admissions@uwtsd.ac.uk
www.uwtsd.ac.uk

Walsall College
Tel: 01922 657000
Email: cegan@walsallcollege.ac.uk
www.walsallcollege.ac.uk

Warrington Collegiate
Tel: 01925 494390
Email: admissions@warrington.
ac.uk
www.warrington.ac.uk

Warwickshire College Group
Tel: 0300 456 0049
Email: he@warkscol.ac.uk
www.warwickshire.ac.uk

West Cheshire College
Tel: 01244 656555
Email: info@west-cheshire.ac.uk
www.west-cheshire.ac.uk

The University of West London
Tel: 0800 036 8888
Email: courses@uwl.ac.uk
www.uwl.ac.uk

University of the West of England, Bristol (UWE)
Tel: 0117 328 3333
Email: admissions@uwe.ac.uk
www.uwe.ac.uk

University of the West of Scotland
Tel: 0800 027 1000
Email: admissions@uws.ac.uk
www.uws.ac.uk

University of Westminster
Tel: 020 7915 5511
Email: course-enquiries@westminster.ac.uk
www.westminster.ac.uk

Weston College
Tel: 01934 411409
Email: he.unit@weston.ac.uk
www.weston.ac.uk

Weymouth College
Tel: 01305 764733
Email: roz_osborne@weymouth.ac.uk
www.weymouth.ac.uk

Wigan and Leigh College
Tel: 01942 761605
Email: centralapplications@wigan-leigh.ac.uk
www.wigan-leigh.ac.uk

Wirral Metropolitan College
Tel: 0151 551 7777
Email: wmc.enquiries@wmc.ac.uk
www.wmc.ac.uk

University of Wolverhampton
Tel: 01902 323505
Email: admissions@wlv.ac.uk
www.wlv.ac.uk/apply

University of Worcester
Tel: 01905 855111
Email: admissions@worc.ac.uk
www.worcester.ac.uk

Writtle College
Tel: 01245 424200
Email: admissions@writtle.ac.uk
www.writtle.ac.uk

Yeovil College
Tel: 01935 845454
Email: ucy@yeovil.ac.uk
www.ucy.ac.uk

University of York
Tel: 01904 324000
Email: ug-admissions@york.ac.uk
www.york.ac.uk

York College
Tel: 01904 770397
Email: admissions.team@yorkcollege.ac.uk
www.yorkcollege.ac.uk

York St John University
Tel: 01904 876598
Email: admissions@yorksj.ac.uk
www.yorksj.ac.uk

The colleges and universities in Appendix 1 are listed on the UCAS website as they offer Higher Education courses (HND courses, degree and foundation degree courses). Some Foundation providers offer Further Education courses only and so are not listed. Direct applications for these colleges can be made through their websites. The University of the Arts London comprises six colleges: Central St Martins, Chelsea School of Art, London College of Communication, Wimbledon School of Art, Camberwell School of Art and London College of Fashion; courses offered by these colleges are listed under the University of the Arts course details.

Appendix 2: Glossary

Studying art and design

Adjustment
Students who have achieved the grades or scores required for their degree course but have done better than expected can use the UCAS Adjustment window in August to look for courses that require higher grades.

Art Foundation
A one-year further education course offered by universities and colleges, commonly taken by students who want to apply for art or design degree courses at university.

Art school
University departments of art and/or design and stand-alone colleges specialising in the teaching of art and design are commonly referred to as art schools.

Clearing
Students who have applied for degree courses but either have no offers or who have not achieved the required grades for their offers in August can use the UCAS Clearing scheme to apply to other universities.

Extra
Students who have applied for degree courses but who receive no offers can approach more universities from February of the year they intend to go to university using the UCAS Extra system.

Foundation degree
A two-year higher education course.

Further education course
A course below degree level, such as a Foundation course.

Higher education course
A degree-level course.

Higher National Diploma (HND)
A higher education course, often of two years' duration. On some HND courses, students can add a third year to reach degree level.

Portfolio
This can either refer to the case in which an artist carries his or her work or to a body of work that represents the artist's areas of specialisation or interest.

UCAS
The Universities and Colleges Admissions Service, the centralised university applications system for degree course applications.

UKPASS
The UCAS system for postgraduate applications to selected universities.

Ways of describing art and design

(Be warned: these are general descriptions, not definitions, and there are as many ways of categorising types of art and design as there are styles of art itself – and no two people will ever agree on exact definitions.)

Art
What is art? A good question, and one that people have been asking ever since prehistoric man drew pictures of animals on cave walls. For many people, art is a way of communicating their hopes, fears, beliefs or feelings in a predominantly visual way.

Abstract art
Art that relies on colour, shape and form to evoke feelings and emotions; or to express ideas.

Architecture
The design of structures and buildings.

Art history
The study of how changes in styles of painting, sculpture and architecture throughout history relate to or are caused by social, technological or political changes and events.

Ceramics
The design and creation of objects using clay or related materials.

Conceptual art
A work of art in which the idea behind the piece is more important than the actual piece itself.

Contextual studies
The study of the theory of art, taking into account political and social influences, the use of materials and techniques.

Crafts
Work created in studios that has a practical use, such as pottery, jewellery and glassware, typically handmade.

Design
Designers create things or ideas that can be used for practical purposes, for example websites, furniture and clothing.

Environmental art
Art created out of natural materials as part of the landscape.

Fashion
The design and production of clothes, shoes or accessories, such as handbags.

Figurative art
Art that recognisably depicts people or things.

Fine art
Fine art courses cover the traditional elements of art, such as painting, drawing and sculpture. Fine art practitioners generally focus on producing works that create emotional responses rather than having practical uses.

Performance art
Art that relies on the artist using him- or herself, or other participants, as the artwork.

Photography
The use of light to create still or moving images on light-sensitive surfaces. Photography courses can include film and video.

Printmaking
Creating images by transferring ink or other pigments onto paper, cloth or other surfaces using another surface, such as wood, etched metals, silk screens, etc.

Textiles
Creating cloth using techniques such as felt-making, knitting and weaving.